JACKTOWN

JACKTOWN

HISTORY & HARD TIMES
AT MICHIGAN'S FIRST STATE PRISON

JUDY GAIL KRASNOW

THE
History
PRESS

Published by The History Press
Charleston, SC
www.historypress.net

Front cover, top left: courtesy of Jackson Historic Prison Tours; *top middle*: courtesy of Jackson Historic Prison Tours; *top right*: courtesy of the Michigan State Archives; *bottom*: courtesy of Jackson District Library.
Back cover: courtesy of Jackson District Library; *insert*: author's collection.

First published 2017

Manufactured in the United States

ISBN 9781467135238

Library of Congress Control Number: 2016950698

Notice: The information in this book is true and complete to the best of our knowledge. It is offered without guarantee on the part of the author or The History Press. The author and The History Press disclaim all liability in connection with the use of this book.

Dedicated to the Ghosts of Prison Past. Their hard labor built the town of Jackson, Michigan, into a leading industrial city in the heyday of the Industrial Revolution. Their stories were swept under the rug, ignored and unheard for far too long. I am proud to have swept them out into the open for posterity. Those who spent time on the Inside in what became known as "Jacktown" deserve this final recognition. Likewise, so do the reformers of the past who recognized that humane treatment elicits humane response, even from those behind bars.

Contents

CONTENTS

FOREWORD

Just as history is never complete, neither are the stories and tales of Michigan's first state prison in Jackson, Michigan. Perhaps the most important lesson is how essential the prison, the inmates, the keepers/guards and the wardens were to the development of Jackson. This book is a fascinating look inside Michigan's first prison, sometimes from the point of view of the guards and sometimes of the inmates, all of whom were doing time, hoping and praying that they would make it through the day and maintain their humanity.

Between 1830 and 1840, the population of Michigan grew from 31,000 to 212,000. Most of the settlers came to farm, and by growing more than enough to feed their own families, they began to sell their crops. Mills were built, and in Jackson, wagon and carriage factories were needed to haul products to market. So it was that the prison in Jackson provided the cheap labor for the town's factories to thrive. The population grew, bringing the railroad and turning Jackson into a remarkable, fully engaged, leading Midwest industrial city. The Industrial Revolution had begun, and with the prison and railroads (seven different railroad lines came to town), Jackson was helping to lead the way.

On May 1, 1918, Michigan became the first state to pass Prohibition; the entire nation followed in 1920. The infamous Purple Gang, which rose to power in the 1920s, comprised hooligans, bootleggers, racketeers, hucksters and murderers. Many of them ended up in "Jacktown." Their stories both inside and outside the walls of the prison are part of Jacktown lore.

THE TOURS

I remember feeling overwhelmed and somewhat intimidated by Judy's incredible wealth of knowledge about Jacktown and our tours in the beginning. The tours have changed the image of Jackson's prison history from negative to positive, bringing thousands of tour visitors to Jackson and making it a prime attraction, particularly for history buffs.

If more of Michigan's early prison history could be written with the clarity, vigor, storytelling and warmth of this book, more such history would be read. Certainly, there is pain in these pages. There is also rage, horror, ambivalence, greed and corruption.

Judy has captured the incredible courage and human spirit exemplified by John Purves, who was "Captain of the Night Keepers."

Judy, Steve Rudolph (associate and guide) and I have been forever transformed by the stories that are in this book.

—James W. Guerriero
Retired director, Jackson County Parks; founder of Jackson County's Civil War Muster,
the largest in Michigan, now in its thirty-second year; member, board of directors,
Cascades Park Foundation; and Jackson Historic Prison Tours guide and advisor

Preface

FROM MIAMI, FLORIDA, TO MICHIGAN'S FIRST STATE PRISON

As a storyteller, folk singer and portrayal artist with a passion for bringing history to life, I lived the life of an itinerant performance artist. For twenty-six years, my home base was Miami, Florida. I'd traversed every corner of that state as a Chautauqua Scholar for the Florida Humanities Council. Until, one day, stuck in the usual I-95 traffic on the way to a performance in April 2007, I flicked on National Public Radio. Precisely at that moment, a report began on WDET (Detroit) about an old prison in Jackson, Michigan, being repurposed into a resident artists' community. Tidbits of Jackson prison history were interspersed with details about how this project would be an incubator for Jackson and other towns, showing how the arts could economically rejuvenate formerly thriving communities where bygone industrialism had once flourished.

My van grew totally silent except for the pounding of my heart. The thought of moving to an old prison to live within a community of artists ignited my imagination. I did some old-fashioned texting as the traffic crept along. I pulled a notebook and pen out of the glove compartment, leaned on the steering wheel and wrote down the number to call about the project, Armory Arts Village. Late that evening, I left a voice mail. At 8:20 the next morning, my phone rang. It was the marketing director. Her enthusiasm resulted in my immediately booking a flight.

Two weeks later, I donned a hardhat and boots to explore Michigan's first state prison. It had closed in 1934; was used as an armory in World War II, the Vietnam War, Gulf War and Iraq War; was closed again in 1996;

and was now becoming the only old prison in the world to be turned into a residence with a focus on art. The West Wing, Michigan's very first brick, mortar and stone cellblock, had been turned into a drill hall. But the historic room still held the huge bars on its tall windows and the stones and brick laid there by the inmates themselves. As I stood there gaping at the magnificence of a room that I would come to learn held much misery, I felt the spirits of the ghosts of prison past. Walking through the old building, in my mind's eye I could see guards walking through the huge rusted iron gates that still hung crookedly on their hinges. Outside, I felt entranced by majestic, twenty-five-foot-high prison walls with castle-like guard towers.

Jackson seemed a sleepy small town compared to bustling Miami. However, among other things that caught my eye were the banners hanging along Michigan Avenue reading, "Jackson Annual Storytelling Festival." This was the second of two signs: the WDET report and now these banners. The latter promised a storyteller's dream come true: a town with an annual storytelling festival.

I returned home imbued with a longing to uproot myself and move to the old prison. My children, on hearing of this possibility, cried out, "Mom! Are you losing it? Mom! It snows big-time in Michigan!"

My older sister had a different take. I'd had three failed marriages, the first giving me my four wonderful children. As I like to say, three strikes and you're out! My sister said, "Yeah, old prison—what's his name?" My eighty-eight-year-old Aunt Pauline said, "Honey, if you don't do this now, when you are my age, you will look back and say, 'I wonder what my life would have been if I'd gone to that old prison?'"

I listened to the wise matriarch of the family, my aunt, and decided to give it a try, but not before returning to Jackson in July to "test my sanity." At a tailgate party attended by twenty-two artists from all over Michigan and other states, I met Catherine Ewert Benson. She is the granddaughter of the last chaplain at the old prison, Albert M. Ewert. Catherine was archiving her grandfather's prison memorabilia. She took me to her house, where I became hooked on the prison history as she let me pore through six trunks of material. We went to the Michigan Historical Museum's archives. I knew this was a treasure-trove of history for a storyteller. Catherine wanted me to portray her grandmother, who, along with her grandfather, was deeply involved with the prison.

This visit convinced me that it was, as Aunt Pauline said, something I should try. Wooden blocks hung where an apartment entrance would ultimately be located in the repurposed prison. The artists in attendance at

the tailgate party could walk around, still with hardhats on, and choose the space that would be their apartment from among the cellblocks being torn apart. I wandered the length and breadth of the huge building, drawn to No. 107. A half-dismantled cell stood where, unbeknown to me, my kitchen area would be. For whatever reason, I felt this area was "home."

Returning to Miami, it suddenly hit me: how would I sell my town house? It was the nadir of the housing market, and the dwelling that I had bought eighteen years prior, though it had increased tremendously in value, was now plummeting in worth. Who would buy it? At what price?

Then came the third sign: Dr. John May, who lived in the complex where my town house stood, knocked on my door. "Judy," he said, "word has it that you are going to prison."

"No, no, John, let me explain."

"Whatever," he replied. "If you are leaving, I would like to buy your town house for my granddaughter. Name your price." I did. He accepted! He said I could remain there rent-free, paying only for utilities, until I was able to leave. I thought, "Someone up there is giving me a message": the WDET report, the storytelling festival and the sale of my house in hard times!

I left on December 15, 2007. I said goodbye to my precious banana tree, tearfully hugged my beloved friends and took off for Belgium to spend the Christmas holidays with my daughter and her family.

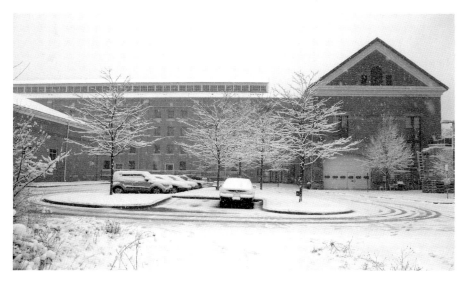

A winter view of the prison, now Armory Arts Village, looking south. When the artists' village opened, it was listed by MSN.com among the top ten most-unique dwellings worldwide. *Author's collection. Photographer, Jon Tulloch.*

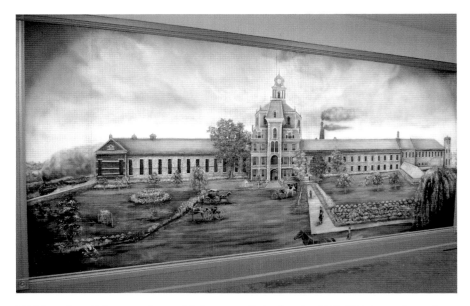

Michigan State Prison was the world's largest walled prison by 1892. This image hangs in the lobby at Armory Arts Village. *Author's collection. Photographer, Jon Tulloch; muralists, Hector Trujillo and Jean Weir.*

Amid a raging Michigan blizzard, on January 5, 2008, I arrived at my new home.

I was the thirteenth person to move in. No artists had yet been assigned studios. On that cold night, not one painting hung on the hallway walls still bearing the old prison bars. Seven large murals depicting prison history had not yet been created—those would come a few years later, when, as historical director, I requested and received a grant from the Michigan Humanities Council. The new apartment building was bereft of anything but the remnants of the old prison: original floors, brick, stone and concrete added in the late 1800s. Each apartment had its own layout, fresh paint, plumbing, heating, air conditioning, kitchen appliances and closets. But the public areas, though cleaned and painted, looked close to how they appeared in the prison years. The integrity of the building and its past remained honored. I reached what was now a door to an apartment—my apartment: No. 107. Like a ton of bricks, it hit me: "What have I done?" When I finally got the key in the door and opened it, I was amazed at what I saw: a beautiful, spacious apartment with the old brick wall that once held cells.

People entered the building and went to the rental office, asking questions about what the place had been prior to Armory Arts. Knowing I was

studying the prison's history, the office called me to answer these questions. My answers turned into mini-tours. The mini-tours turned into longer tours. Before I knew it, I had established a tour business. Storytelling led to the Jackson Historic Prison Tours, five-star-rated on TripAdvisor and Facebook.

I have come to believe that there are no coincidences. I truly believe the ghosts of prison past found an adventurous, divorced storyteller with an empty nest. "That's the one," they whispered. "She can do it! We've lain swept under Jackson's rug for far too long. We built Jackson into a thriving industrial city in the heyday of industrialism. Our stories should be heard!"

ACKNOWLEDGEMENTS

I offer many thanks and acknowledgments to the following: National Public Radio's WDET Detroit, which reported in April 2007 about the repurposing of an old prison in Jackson, Michigan; Catherine Ewert Benson, who, while archiving the prison memorabilia of her grandfather Chaplain Albert M. Ewert, introduced me to the fascinating history of Michigan's first state prison; Scott Fleming and Jane Robinson for suggesting I make historic tours of the old prison my "day job" at Armory Arts Village; Peter Jobson of Excel Realty for use of his building and property to keep its history alive; the Michigan Humanities Council for funding the grant for seven large murals depicting the prison's history; Hector Trujillo and Jean Weir for painting the magnificent murals; Lou Cubille for his artistic renderings in the book depicting scenes of which there are no recorded photos; for support, friendship, constancy and loyalty: Bob Lazebnik, Jean Becker Walsh, Dr. Robert Walsh, Bart Hawley, Karen Hawley, Don Hyink, Rosa M. Douglass and Carrie Sue Ayvar; Janet Kasic, director of Circle Michigan, for all the promotion of the tours and imparting essential knowledge regarding tourism; all the corrections officers, retired wardens, former prison residents and descendants of former employees or inmates of Michigan's first state prison and the State Prison of Southern Michigan who eagerly shared their stories; Phil Willis for his belief and investment in the tours; and most of all Jim Guerriero and Steve Rudolph, my acquired brothers and *amigos*, without whose belief, shared passion in the prison history and

commitment to the tours and company through thick and thin I could not have continued, for whom I am forever grateful and with whom I am constantly reading, listening and learning more and more—and more—prison history.

1

The Establishment
of the Penitentiary

In colonial times, settlers brought to America the English concept of jails to house paupers, vagrants, drunks, prostitutes, thieves and murderers. Punishments reminiscent of medieval times were designed to publicly humiliate a person having committed a crime. The wooden stocks, placed in the public square, held prisoners standing or seated on a hard wooden bench with their hands, head and sometimes feet locked tightly in wooden holes. For many hours, sometimes days, they'd remain in this uncomfortable position in hot sun, cold winds, rain, sleet or hail. Passersby would toss rotten eggs, tomatoes and other items while heckling them, bringing shame to those taunted and to their families.

Other carryovers from medieval times consisted of the cuckold chair, in which a wife who had betrayed her husband or talked too much and belittled him by being disobedient would be seated, strapped in and paraded through town, sometimes dunked under water in the local creek or river for long periods just short of drowning. A husband who had betrayed his wife was strapped to a ladder or chair and marched through town as outraged citizens blew horns, banged on pots and pans and threw objects at the unfaithful man while calling him names. The Salem Witch Trials took place in Massachusetts in 1692. A couple of hundred young girls and women accused of being witches were imprisoned, tried and hanged. One was even pressed to death. Several died of cold and hunger in the miserable jails in which they were confined.

The premise of punishment was based on the biblical story of Adam and Eve, temptation, sin, punishment for having sinned and punishment for breaking any one of the Ten Commandments. Ridding towns of "witches" was another means of "keeping the devil away." In colonial America, small jails were the place to be locked up for committing a crime. Hanging was often the result of arrest. Vengeance as opposed to reason more often served as the judge of what punishments were meted out to a violator.

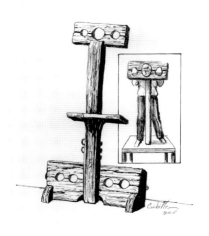

Colonial-era stocks were a means of public punishment prior to the era of penitentiaries. *Author's collection. Illustration, Armory Arts Village artist Lou Cubille.*

As the 1800s rolled around, and agriculture gave way to industry with the advent of the Industrial Revolution and burgeoning of factories to utilize the many machines being invented, punishments and incarceration took on a whole new meaning. America began to utilize jails as the holding place for criminals awaiting trial. Once convicted, the convict's place of incarceration became huge prisons called penitentiaries. These huge penitentiaries came to be known as the "Big House." The concept behind state or federally run large houses of incarceration resulted from populations rapidly increasing throughout states as more settlers arrived and from the idea that criminals should not only be punished but should also be rehabilitated. Public humiliation and vengeance were no longer the answer. Instead, locked away from society, the prisoner who wished to be part of society again would repent, improve and go out a functioning citizen.

In 1816, a prison was built in Auburn, New York. This prison, though still called a prison, set the penitentiary movement in motion and became the prime example of what would become the American-style "Big House." Here, the inmates would be simultaneously punished and rehabilitated by providing cheap and forced labor for factories built on the prison grounds inside prison walls. Forced labor of any sort was the convict's lot, and a prisoner had no choice as to the factory or type of work he'd be assigned to. He would learn skills that would serve him when and if he attained release. Auburn served as a maximum-security prison, soon to be called a

penitentiary. A wooden statue of a Revolutionary War soldier carved in 1821 stood atop the Administration Building. By 1848, a copper edifice made in the foundry by the inmates had replaced the statue, now weathered almost beyond recognition. The new statue, called "Copper John," initiated the saying about those committed to Auburn, that they were "going to work for Copper John."

In contrast, in 1829 in Philadelphia, Eastern State Penitentiary opened and ushered in the use of the word *penitentiary* for large houses of incarceration. The innovative term evolved from the words *penance* and *penitence*. Jail had now officially become a place where one would be held while awaiting trial or for short periods of time for unruly behavior such as drunkenness.

Eastern State Penitentiary was based on the Quaker idea that one should do "penance." The inmates of Eastern State were kept in solitary cells with no contact whatsoever with other inmates. Each cell had a solid door facing the main walkway of each cellblock row as well as a lattice door on the opposite side that led out to a small, enclosed individual yard. For one hour each day, inmates went out to their solitary yards to look at the sky and hear the chirping of birds while further contemplating their wrongdoing and the pathway to bettering their lives. Other than the short time outside with nature, all time was spent in solitude. Meals were eaten alone. Walls, painted white, would inspire purity. Labor, such as sewing garments and making shoes, was also a solo activity. Penance, silence, constant time to be alone with one's thoughts would, the Quakers believed, bring a man to his senses and steer him to a rehabilitated life. More often, though, what this isolation brought was insanity. Furthermore, isolated imprisonment did not fit the era of growing industrialization. The Auburn Prison system, however, did fit this new era.

With the mushrooming of factories throughout the North, the Auburn Prison established a system that fit perfectly with the growth of industrialization. The prison walls surrounded what became a mini city of factories. Punishment included the long and tiresome hours an inmate had to work. Such hours were characteristic of nonprison factory labor, too, during the Industrial Revolution. Factory conditions were anything but pleasant. The noise was often deafening, and the air was filled with unhealthy fumes, flying debris and lint that often caused brown lung disease. Obviously, the prisoners could not organize unions or fight for better working conditions like nonconvict laborers. The rehabilitation aspect of the Auburn system allowed prisoners, often with little or no education, to learn skills and earn some money to be put into an account, accessible when the prisoner

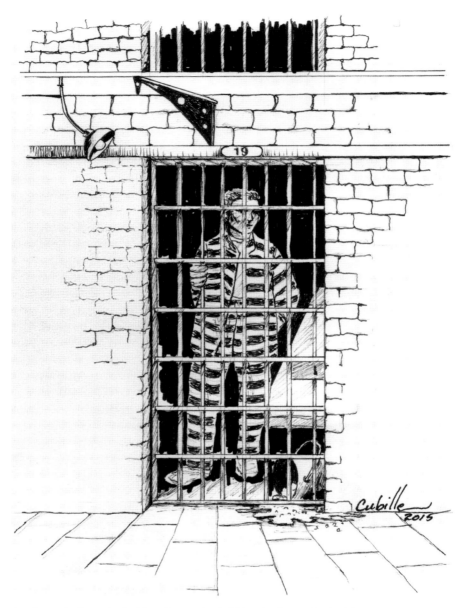

A prisoner is shown locked in a four-and-a-half-foot by five-and-a-half-foot cell with an overflowing honey bucket. *Author's collection. Illustration, Armory Arts Village artist Louis Cubille.*

returned to society upon release. An inmate earned approximately 33.5 cents a day working in a factory, compared to the $1.50 that nonconvicts made. The inmate would receive 5.5 cents, which he could spend in the commissary or save for hopeful release. He could also send money to needy family members suffering economic plight caused by a husband's or father's incarceration. Of the 33.5 cents paid to inmate laborers, 28 cents went to the state government.

An agent for the state contracted with factory owners. This same agent served as the warden. It wasn't until 1880 that the jobs of agent and warden were separated and the agent did the contracting while the warden ran the penal institution. Where farming was part of the labor that inmates provided, 33.5 cents per day was also the sum paid for each convict working on a farm. In addition, some inmates worked at factories in town. They were marched to the factories wearing iron balls weighing between sixteen and twenty-one pounds and chains wrapped around their ankles. It was a win-win situation for the factory owners and the state and, to some degree, for the inmates. The latter earned a little money, gained skills, had respite from boredom and felt a degree of accomplishment at the end of the day. But the contract system, its forced labor, quota system and punishments for lack of fulfilling quotas presented many drawbacks, as will be described later. Lack of freedom and control over one's life is never pleasant and holds many dangers. Breaking societal rules and laws has always been a darkly dangerous thing to do.

Throughout human history, miscreant behavior has provoked revenge. Offenders suffered merciless death, brutal punishments or banishment from the community. Whether acknowledged or not, vengeance lies behind most punishment. Public hangings, the stocks, cuckold chairs, whippings and other forms of humiliating and brutal physical penalties didn't stop crime. To this day, American prisons hold more inmates than those of any other country in the world. Punishment and incarceration have not thwarted crime. Additionally, what constitutes a crime can and has changed throughout history.

Some actions have more or less always been considered crimes, such as robbery, larceny, murder and sexually deviant acts. The criminal status of other actions has evolved with changing times. For example, imbibing alcohol may cause some who drink to engage in miscreant behavior. Yet, if alcoholic drinks are taken away, as happened during Prohibition, what formerly had not been a criminal activity now became one. This led to the arrest of thousands of people formerly not considered criminals. The demand for liquor led to bootlegging, which in turn led to criminal organizations like the

Purple Gang of Detroit and the Reid River Gang and to underworld leaders like Al Capone, Harry and Phil Keywell and Leonard "Legs the Squealer" Laman. Criminalizing liquor led to a spike in kidnappings, robberies and murders, resulting in an almost overnight jump in the prison population.

The famous lawyer Clarence Darrow, the defense attorney at the controversial "Scopes Monkey Trial," wrote in a book, *Crime, Its Cause and Treatment* (1922), "The idea that crime is prevented by punishment, if believed, would require that the young should visit prisons that they might realize the consequences of crime, and that all executions should be public and performed on the highest hill." Darrow believed that crime reflected the ills of society, such as poverty and lack of education, as well as parenting affected by ignorance and poverty. He also recognized that those with money who broke the rules often went unpunished. As for vengeance, Darrow said: "The manifestations of the mind and the actions of men are part of the physical world. Vengeance is planted in the structure of man. Punishment is based upon vengeance....One needs only to note the hatred of the good for the one accused of crime and the zeal that is shown for a man hunt, to realize how deeply the feeling of vengeance is planted in the structure of man."

He further stated:

> *No matter what one may think of the so-called criminal and his responsibility, or quite regardless of whether we feel pity or hatred, the great mass of the community will not suffer one who has little self-control to interfere seriously and directly with peace and happiness of the community in which he lives. Taking away the liberty of another has only one justification. The great mass of people in any community must and will act for self-defense....Hatred should have nothing to do with it.... Punishment, in the proper meaning of the term, cannot be justified by any reasoning. Punishment really means the infliction of pain because the individual has willfully transgressed....If justice and humanity shall ever have to do with the treatment of the criminal, and if science shall ever be called upon in this, one of the most serious and painful questions of the ages, it is necessary, first, that the public shall have a better understanding of crime and criminals.*

In the mid-1800s, with the establishment of the penitentiary, the employment of public executions, public whippings, stocks and pillories ceased. In addition, the idea of throwing a man into a jail cell and leaving

him there to grow ill and forgotten was abandoned. The penitentiary, by taking away the criminal's freedom, would provide, so it was believed, proper punishment. Physical and mental punishments would now take place behind the prison walls, to be witnessed only by those either employed or incarcerated there. A law adopted by the U.S. federal government, known as the Code of Silence, prevailed. Not only was one's freedom lost with incarceration, but an inmate could not speak unless an official initiated a conversation. Contamination of one prisoner by another would, therefore, not be possible. Once inside the penitentiary, inmates talking to one another in cells, at meals, in the yard or at work was forbidden. As for rehabilitation, it was believed that working for a scheduled number of hours each day would give a man something to do, new skills to learn, a little money in his account and a sense of having done something purposeful by the end of the day. The Auburn concept of the penitentiary fulfilled these dual goals.

As the number of miscreants in America's newly formed states was growing too fast and too large to be housed in jails, the Big House became the new residence for those who broke the law. It replaced the filthy jails where idleness plagued convicts; where lynch mobs often waited outside for an opportunity for vengeance; and where, as in England, a person who committed eighteen petty crimes (such as stealing a loaf of bread) spent their time before facing the gallows.

When Michigan entered the Union as the twenty-sixth state, it joined this novel wave of dealing with those whom society considered criminals. Upon gaining statehood in 1837, Michigan's legislature deemed it necessary to establish its first state prison. A state penitentiary would give prestige and offer the promise of industrial success to the city in which it stood. The numerous factories the prison would contract, combined with the cheap labor of the convicts, would ensure a high output of manufacturing, a variety of products to be shipped and sold throughout the nation and a continuing source of economic stability.

MICHIGAN BECOMES A STATE, AND THE BATTLE FOR ITS FIRST PRISON BEGINS

F irst as a territory and then as a state, Michigan lured many settlers with its abundance of fertile land and ample water. Jackson had all of these. The Grand River and many streams and lakes created farms that thrived and generated water power for flour mills. The presence of forests meant that land could be cleared and the wood used for construction. Marshlands afforded continuing water sources. Jacksonburgh (the original name, soon changed to Jackson) was named, like many other counties, after Andrew Jackson, a powerful political innovator with stains upon his career that included the genocidal Trail of Tears. However, in 1837, his rise to power and populist beliefs made his name perfect for a growing town. Jackson, Michigan, appeared a promising place to start a new and successful life.

As Jackson's population grew, so did the introduction of all types of machinery. At the height of the Industrial Revolution, owning and operating a factory became a lucrative business. With water, a huge oak forest, rock quarries, marshlands, abundant wildlife, fertile soil and an ideal location between two growing, major cities—Chicago and Detroit—Jackson seemed an ideal place to settle for those with an industrial inclination.

Surrounding areas in Michigan offered enticement, too—towns and cities with names like Adrian, Ann Arbor, Napoleon and Marshall. While it was a territory, Michigan's population grew. As a state, it was certain to draw an even greater population. As legislators and other town and city planners knew, a greater population meant, on the whole, good, industrious people. They also knew that humans have flaws. A growing population would also

bring those who could not follow the laws, would commit crimes or would prove mentally unstable.

In 1836, while governor of the Michigan Territory, Steven T. Mason stated the need for a penitentiary. He had been appointed acting territorial secretary at the age of nineteen. At twenty-two, he was appointed territorial governor. Known as the "Boy Governor," "Young Hotspur" and the "Stripling," Mason proposed that "application be made to Congress for a donation of land to aid in the erection of a penitentiary, competent to meet the requirements of society." In March 1837, three months after Michigan was admitted to the Union, due in great part to a survey initiated by Mason, this youngest governor in American history was instrumental in the passage of an act recognizing Michigan's need for a state prison.

The legislature appointed three men to a committee to determine what type of prison should be built and what site it should be built on. Jacob Beeson, H.P. Cobb and H. Stevens were appointed to research existing prisons before a decision would be made as to the type of prison suitable for the new state. As mentioned in chapter 1, the Quakers were instrumental in the establishment of the Eastern State Penitentiary, where inmates lived and worked in solitary cells. Solitary imprisonment did not suit the growing era of industrialism, which required laborers to work in factories. Hundreds of workers were needed to operate the newly invented and ever-growing machines that now produced goods formerly made by individual artisans in their own shops and homes.

The Quakers persisted in promoting their belief in solitary incarceration as rehabilitative imprisonment. They successfully fought for the passage in 1794 of a law in the state of Pennsylvania that limited the list of capital crimes to first-degree murder and prescribed imprisonment for all other offences. This act marked the end of the colonial ideas brought over from Europe regarding incarceration. The Quakers' abhorrence of cruel and barbarous punishments, such as whipping, mutilation and hanging, for minor offenses played a leading role in the reforms and changes that prevail today in both Europe and America. They fought for—and won—the battle for imprisonment under decent conditions as a substitute for corporal and capital punishments. As a result of their efforts, the codes that were written into Pennsylvania law spread quickly to other states.

The Auburn, New York penitentiary system was selected for the future "Big House" in Michigan. Codes of treatment of prisoners won by the Quakers were to be incorporated into the state laws related to operating the penitentiary. In keeping with the Quaker principle, the inmates would

remain silent and contemplate their misdeeds. In an effort to prevent "contamination"—the spread of bad thoughts, actions, criminal behavior or unified plans to rebel within the prison walls—a strict code of silence would be enforced: no talking unless conversation was initiated by an authority, including talking to oneself in one's cell. As stated, this soon became federal law and applied to all new penitentiaries across the nation.

Not only in Michigan, but in the other states of the Union as well, the Auburn system became the prison arrangement of choice. It proved practical and far less costly than the Eastern State Penitentiary system. The Auburn system would make a prison self-sufficient and contribute money to the state in the form of payment taken from the earnings of each and every inmate employed in each and every factory and on each and every prison farm. The most indisputable argument in its favor was that, with a self-supporting prison, there would be no cost to the taxpayer. Michigan's committee of three investigators unequivocally recommended the Auburn system. In 1838, the legislature authorized the building of the state penitentiary in Jackson, but not before several other Michigan cities submitted their own proposals to the newly formed state government.

Jackson Proves Victorious

It may seem peculiar that newly established cities and towns would compete to have prisons. However, during the Industrial Revolution, a city or township that gained a state prison was certain to successfully move into the new industrial era. There was vast potential for those wishing to build factories as part of a penitentiary, and the setting, with its cheap, forced labor, was ideal. Undoubtedly, a huge prison would bring great stature and wealth to a town. Prison factories would bring railroads to transport products all over the nation. Railroads would bring visitors. And visitors would require hotels to sleep in and restaurants in which to eat. Economic success could not help but come to a town that was home to a big house!

Proposals were sent to the newly formed state legislature by Jackson, Ann Arbor, Adrian, Detroit, Marshall, Napoleon and Lansing. Each town stated why its location was the prime one for the prison. However, certain stipulations were necessary in order for the prison to be built. One required at least twenty to thirty acres of land, and that land had to be near the center of town. Why would a prison need to be near the center of town? An aspect

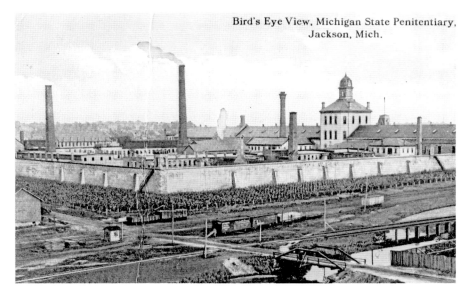

Bird's Eye View, Michigan State Penitentiary,
Jackson, Mich.

This is an overview of North Street, the Grand River and the bridge prior to the addition of a train entrance into the prison grounds. *Courtesy of Jackson District Library.*

of the Auburn, New York system not only had inmates working in factories within the prison walls, but some were marched to work at factories within the town, too.

Jackson was graced with five pioneering, business-oriented men who owned many acres of land near the center of town. It was along the Grand River, much of it marsh or swampland that needed draining. The water, however, would ensure good farming. The prison would not only produce industrial goods. It could accommodate farms, where inmates would also be contracted out, producing food for the prison and crops that could be distributed throughout Jackson, surrounding towns and other states. However, this land also posed problems. It would require more grading and the construction of the necessary dam and mill. Lying near a mosquito-filled swamp darkened by the presence of mighty oak and tamarack trees, the land held the threat of disease. At first, Marshall was favored by the three appointed commissioners. Napoleon ran a close second, as it had a small quarry of sandstone, a major building material at that time.

In keeping with the political maneuverings in the newly formed state, businessmen and other civic leaders began backroom operations with local and state politicians and called on Jackson citizens to pressure politicians. Among the arguments Jackson offered in its favor was that

it was closer to the criminals because it was closer to Detroit, a big city that would certainly "breed crime." Jackson also had access to more sandstone, via its huge sandstone quarry in Spring Arbor, than did the other prison competitors. Sandstone would be a vital necessity for building a stone, brick and mortar prison.

The candidate towns also competed as to which could contribute the largest number of acres for the prison and its farms. Jackson came through with sixty acres. This land, contributed by businessmen anxious to have the prison, would be donated to the state—not paid for by the state, as called for in the other towns' proposals. Henry B. Lathrop contributed twenty acres; William Ford offered ten; Russell Blackman, Henry Gilbert and James Ganson contributed the rest. All sixty acres were smack-dab in the center of town. These merchants and land speculators had arrived in 1835 and were all born in various counties of upstate New York. Ganson Street, constructed later and named after James Ganson, crosses what ultimately became Mechanic Street, where the prison would stand. Mechanic Street led (and still leads) directly into the downtown section of Jackson. The

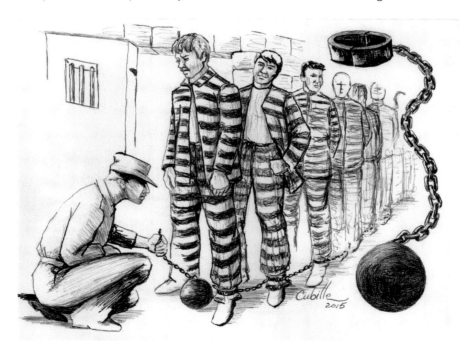

The ball and chain was used whenever an inmate had to go somewhere outside of the prison, such as a factory. *Author's collection. Illustration by Armory Arts Village artist Louis Cubille.*

street lies one block from where the front buildings of the prison would ultimately become its huge front wall. In the 1800s, the sturdy and massive architecture of a penitentiary utilized the front buildings of the prison as the fortress-like front wall. Three walls would meet these front buildings from behind them. On this street, prisoners would be marched into town in their black-and-white-striped uniforms, with balls and chains around their ankles, to factories lining Mechanic Street.

James Ganson came to Michigan under dubious circumstances, fleeing from a scandal involving embezzlement by the Masons, of which he was a member in Kingston, New York. He fared well in Jackson, particularly when the battle for the prison ended in victory for the town. The process was definitely not the purest, and the notion of corruption would continually arise throughout Jackson's long prison history. However, this victory, achieved by a legislative vote of 5–1, was pivotal. It meant that Jackson would have a continuous, steady and publicly funded source of income. The existence of the prison would turn Jackson into an urban center.

This is an anonymous rendering of the grand-looking Jackson Prison. By 1892, it was the largest walled prison in the world. Townsfolk of all ages walked by daily. *Courtesy of Jackson Historic Prison Tours.*

Against the cries of "unfair and a better location" uttered by disgruntled officials in Marshall and Napoleon, Jackson won the battle to be the locale for the first Michigan State Prison, or MSP, as it was called. The facility would later be referred to as "Jacktown." Of those convicted and sent there, the saying would be spoken, "Ay, so you're goin' to Jacktown!"

A myth would later arise regarding Ann Arbor's loss in the bidding for the prison. The town later became the home of the University of Michigan, which eventually turned Ann Arbor into a well-to-do university town with an outstanding school. But in 1838, the coveted prison would create a thriving, wealthy town. The myth claims that a rivalry raged between Jackson and Ann Arbor in 1837 over which of the two towns would be granted the university, not a prison. This myth is false. Ann Arbor desired the prison, just like the other towns engaged in the battle to obtain it. In 1837, universities housed elite white males and were not the huge generators of revenue that so many have become today. Back then, Ann Arbor, having lost the fight to have Michigan's first state prison, was granted the university, which hosted a mere seventy wealthy white male students and ten prominent white male professors.

In the 1800s, a penitentiary with convict labor and factories, not an institution of higher learning, was the prized possession. Jackson won the prize and became home to Michigan's first state prison. However, another conflict in urgent need of a solution soon faced the three commissioners who had chosen Jackson for the Auburn-style penitentiary.

3

THE FIRST HOUSE OF INCARCERATION

A Wooden Fort

The first prisoner to enter Michigan State Prison was John Macintyre, from Wayne County, incarcerated for larceny. Larceny was the crime most committed during the nineteenth century. There were, of course, also cases of murder, rape, incest and child molestation. And there was "habitual imbibing" of alcohol, which led to disorderly conduct of various sorts, including brawls, wife- and child-beating and indecent exposure. However, if one looks through the thick, leather-bound annals listing all the prisoners admitted to MSP during the 1800s, as well as their crimes, lengths of sentences and dates of admission and release, it is clear that the crime most committed was larceny—taking anything of value from its owner with the intent of keeping it. Examples of this crime included shoplifting items from a store and removing something, such as a ring or vase, from a home without the owner's knowledge. Stealing a watch, shoes or apples constituted petty larceny, which carried a penalty of up to five years in prison. Stealing a horse, cow or wagon would constitute grand larceny, which led to ten or more years in prison. Today, the distinction between petty and grand larceny would be the difference between stealing some books and stealing a car. For a defendant to be convicted of larceny, both petty and grand, the following had to be proven, as listed in a chart at the Michigan State Archives describing the differences among crimes misclassified by the general public as "thievery, stealing and robbing":

1. *That the defendant took possession of property owned by someone else;*
2. *That the defendant took the property without the owner's* [or owner's agent's] *consent;*
3. *When the defendant took the property (he/she) intended (to deprive the owner of it permanently/* [or] *to remove it from the owner's* [or owner's agent's] *possession for so extended a period of time that the owner would be deprived of a major portion of the value or enjoyment of the property);*
4. *The defendant moved the property, even a small distance, and kept it for any period of time, however brief.*

John Macintyre, who gained long-lasting fame as the state of Michigan's first prisoner, also became the first convict laborer. What Macintyre helped to build was no stone, brick and mortar penitentiary. It was a wooden fort built with tamaracks, a sturdy tree also known as the eastern larch. It loses its green, pine-like needles in the fall as other trees lose their leaves. The saying developed as more and more prisoners filled Michigan State Prison, "Ah, so you're going to the Tamaracks!"

The fort was bordered on the west by the Grand River and surrounded by a huge oak forest that ran all the way from Jackson to Spring Arbor. This famous oak forest holds many a tale of prison escapes. It also is the historic landmark of the birth of the Republican Party on July 6, 1854, when a state convention of antislavery men was held in Jackson. *Uncle Tom's Cabin,* published two years earlier, created increased resentment against slavery and anger over the Kansas-Nebraska Act, which allowed free territories to become slaveholding ones. Thousands came to Jackson, whose hotels and halls could not accommodate them. Instead, they gathered in an oak grove on "Morgan's Forty" on the outskirts of town. A slate of candidates selected at this gathering won in the elections of 1854, and the Republican Party, known as Lincoln's Party, dominated national politics throughout the nineteenth century. This historic site came to be known as "Under the Oaks." A monument marks the site today.

With Jackson the designated home of the Michigan State Prison, the construction of a fort to house the prisoners began in the oak forest. Because there were so few prisoners at the time, workers from outside the prison community set up camp on the grounds and began building the fort, working alongside the inmates who were present. The nonconvict laborers resided in a longhouse along with the growing numbers of incoming prisoners.

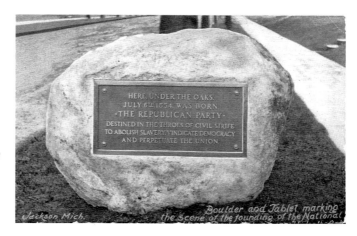

The Under the Oaks historical marker commemorates the formal establishment of Lincoln's antislavery Republican Party on July 6, 1854, in Jackson, Michigan. *Courtesy of Jackson District Library.*

Forts were considered sites of protection. In Michigan, as elsewhere, they stood as mighty sentries, protecting settlers and fur traders from Indian attacks. Discord between the French and English in the 1800s had created a need for these bastions of defense; so why not create a prison that was a fort? After all, at that time, Michigan was considered part of the Wild West.

Matters changed on the foggy evening of June 1, 1840. By then, eighty-five prisoners inhabited the nearly completed fort. As a police wagon pulled by horses entered the doors of the fort—opened to allow entry—twelve of the inmates attempted to escape. They left not only via the entry gate but also dug holes under the fort's fence, climbed over the wooden poles past sleeping (and possibly drunk) guards and swam across the narrow, cold and swift Grand River to the other side, hiding behind bushes, climbing into trees and escaping virtually unseen under the cover of the thick forest mixed with marshland and summer fog. Two of the escapees were caught, and ten men escaped. Based on the handwritten entries in the prison's annals, they were as follows:

1. *#35, Henry Hopkins, admitted on May 5, 1840, sentenced to one year for larceny*
2. *#23, Walter Johnson, sentenced to three years for burglary*
3. *#18, Isaac Bennet*
4. *#27, William J. Parker*
5. *#21, Peter Valee, admitted October 8, 1839, sentenced to two years for larceny*
6. *Henry Vanilla Skonburgh*
7. *Philander R. Myres, sentenced to ten years beginning April 10, 1840*

8. Arastus Brown, admitted November, 1, 1839, sentenced to one year for larceny

9. William Guthm, sentenced for larceny

10. John McGraw, sentenced for larceny

11. Henry Jackson, sentenced for larceny

12. George W. Norton, admitted April 10, 1840, sentenced to ten years for burglary and larceny

It appears that larceny and burglary were their crimes, though records indicate that twenty-two-year-old George Norton, organizer of the escape, had also committed murder (but was not convicted of that crime). Burglary entails unlawful entry, breaking or entering a house, shop or other place of business or dwelling. The burglar's intent is to enter the premises in order to take something or commit some other crime. Robbery, though not mentioned above, it should be noted, involves force. A robbery would be committed, for example, by someone entering a bank and holding hostages at gunpoint or using physical force on a bank employee, including physical threats. In other words, robbery involves forcibly stealing something (as opposed to taking a ring from a store counter when no one is looking). After escaping, the MSP inmates engaged in many robberies.

The ten successful escapees (Hopkins and Jackson were caught) cleverly lived in a hideout protected by the density and vastness of the forest. Their leader was George W. Norton. "Notorious Norton" was also known as a masterful sharpshooter. Under his command, the escapees became known as the Jackson Robber Gang. They were as infamous as the later Jesse James Gang and Florida's Rice Gang. One important factor made them even more dangerous. The other gangs fought against existing gangs for the supremacy of a given territory. The Jackson Robber Gang focused on acquiring money, through robbing banks, stagecoaches and homes, and stealing cattle and horses. In addition to their more odious crimes, they derived great pleasure from frightening women wheeling their perambulators, now called baby carriages, past thick bushes and hedges. While hidden, the men made the sound of rattlesnakes and enjoyed the entertainment of watching the Victorian-clad ladies jump and scream. The mothers were literally terrorized by this and afraid to return to the very spots that were part of their daily walks.

In Spring Arbor, the vicious Jackson Robber Gang stole cattle and horses from a farmer named Joseph Videto and several of his neighbors. No one had been able to catch the bandits. Quite frankly, few if any of

the residents had the courage to face the ten armed and cunning convicts. Joseph Videto dared. He knew they'd return to take another horse or cow from his stock. Determined to save his hard-earned livelihood and its costly, productive stock, Videto sat on his farmhouse porch with a pistol in each hand. He waited, night after night. Then, just as he suspected, the ten armed robbers returned.

Wham! One pistol fired. Wham! The second one sent its bullet through the air. In the darkness, Videto's aim was not what it would be in the daylight. He missed. The sound of the shots brought the gang toward the farmer, ready to have a shootout with whoever was disturbing their night of robbery. When they found not two armed men, but one man firing two guns, the convicts quickly overcame him and beat him bloody, leaving him for dead.

All this commotion traveled through the quiet night air to the neighboring farm of Dorus Spencer. He quickly rounded up some neighbors, took his favorite hunting rifle in hand and accosted the Jackson robbers. A marksman when it came to hunting deer, Spencer killed George Norton, the notorious leader, with one shot. With a second shot, another member of the gang fell to the ground with a badly wounded leg. In the mêlée, two men escaped through the dense forest, never to be found or heard from again. The seven men still alive were now outnumbered by neighboring farmers, all armed. The police were summoned, and the seven were returned to the fort called Michigan State Prison.

Steve Rudolph, a guide and member of Jackson Journeys LLC, the company that runs the Jackson Historic Prison Tours, was inspired by this Wild West story and the fact that Videto's farmhouse still stands. (In fact, Videto's great-grandnephew served as a commissioner in Jackson County for many years.) Rudolph wrote the following poem:

The Legend of Joe and the Jackson Robber Gang

Big George Norton was a bad, bad man,
And his gang was in need of some horses;
So, to his hideout he called his forces
To lay out his plan for a dirty deed—
Old Joe the farmer had all the horses they'd need.
They had been there before. It would be a piece of cake.
They might even find something else to take.
Big George Norton was a bad, bad man.

Old Joe Videto was a mad, mad man.
The Jackson gang was coming tonight;
So, he prepared himself for a deadly fight.
The last time there, the gang threatened his life—
They rattled like a snake and scared his wife.
They sunk his boat and ate his goat;
They even shot holes in his overcoat.
Old Joe Videto was a mad, mad man.

Joe loaded two muskets and sat down to wait
Until early in the morning, down by the gate,
The robber gang was coming like they owned the place;
So, he shot George Norton right in the face.
The whole gang arrived, so he shot George's buddy.
The gang overwhelmed him, left him beaten and bloody.

What do you do once you've stolen a horse?
Well, you go after a cow, of course!
But all that shootin' had alerted a posse,
And they caught that gang stealing Joe's cow, Flossie.
Old Joe mended and returned to health,
And later became a man of great wealth.
Seven escaped convicts went back to prison.
George Norton is buried and has not risen.
His buddy was wounded and eventually recovered.
Two got away and were never discovered.

The Jackson Gang was a sad, sad gang.
If they messed up again, they would probably hang.
They were now put to work building a prison:
Brick and Stone was the new vision.
They are locked up now, but please take note:
If they break out again—hide your goat!

4

Brick, Mortar and Stone Now Pave the Way for the Prison

The escape and ultimate capture of the Jackson Robber Gang convinced both Jackson and the state of Michigan that if a state prison—a genuine penitentiary—was to exist, a fort was not the answer. Plans were put in motion to build a genuine brick, mortar, stone and iron prison. Under the Auburn system of using convict labor, the prison would be built by the convicts themselves. In 1842, the work began.

Across the swift and cold Grand River, the inmates carried heavy stones from local quarries and other materials, such as logs. At first, they laid log bridges across the river—at the time, there were no bridges in the area where the first cellblock, the West Wing, would stand. As the inmates carried their heavy loads on these log bridges, the logs reeled and rolled, and men would fall into the river. It became easier for the workers to simply wade across the water. The image of these men in their striped uniforms, armed guards watching them on all sides, brings to mind scenes in the Disney film *The Prince of Egypt* (1998), with slaves carrying heavy stones to build the pyramids. It was brutally hard work. Every stone that held up the walls of the West Wing, and every brick that made up each cell, was carried, baked and installed by the convicts.

The iron bars that would adorn each tall window were welded by the prisoners. The woven three-foot-thick steel mesh that lined the walls, ceilings and floors also was the result of the hard labor of those incarcerated. This thick steel lining served two purposes. It created a fortress-like structure while obliterating all hope of digging one's way out

of the prison. The lesson of the Jackson Robber Gang's escape would not go unheeded.

The architecture of a cellblock in the early 1800s still possessed a medieval air: small cells in crowded cellblocks with a genuine aspect of "throw them in the dungeon." The cells measured five and a half feet by four and a half feet. That people are known to have been smaller in the nineteenth century does not justify cells so cramped that anyone of average or slightly greater height would not be able to stretch out and would have to sleep with knees bent. The cells in the first cellblock, the West Wing, ran from the back wall of the cellblock to the front walkway used by the guards. The wide walkway led to a ladder at the far end. The guards would climb up and through a hatchway to the gun turret room. In the 12,444 square feet of the West Wing, a row of cells ran the length of the back wall. Three sides of the cells were brick. The front had bricks that framed a narrow set of iron bars. The bars were the only opening in the cell through which air could enter. In front of this long row of cells was an eighteen-inch-wide walkway. Opposite that first row of cells and across this walkway ran another row of cells the length of the cellblock. The man in the back row looked at the brick back of the cell eighteen inches across from him, not at another inmate. Likewise, that second row of cells looked across a walkway at the back of yet another, third row of cells, which looked upon the fourth row in the same manner. Only at the front row of cells running the length of the cellblock and overlooking the wide walkway were there windows on the outer wall above that walkway. The convicts in the first of the four rows would have some light, as their narrow cell doors faced these windows that faced the beautifully coiffed lawn in the front of the prison. In the West Wing, there were a total of 328 cells.

Ventilation in such architecture was unknown. The West Wing had no lights, for electricity had not yet been harnessed and developed into the electric light bulb. There was no heat and no plumbing. Each inmate was given a metal, lidless, rimless bucket. These pails, called "honey buckets" and, in some prisons of that era, "thunder buckets," were emptied once every twenty-four hours. Commercial toilet paper is credited to Joseph Gayetty in 1857. Until that time, various kinds of paper, animal furs, pebbles, leaves and other materials were used. What, if anything, was supplied to the prisoners for this purpose remains a mystery. It is possible that each inmate was given a rag or two. Like all other laundry, these would have been washed biweekly.

The inmates were bathed twice a month with cold well water brought in from hand pumps. In the winter, the temperature in the West Wing was so

cold that the prisoners slept in the pants, jackets, sweaters, scarves, gloves, socks, boots and hats they were given. Underwear was forbidden as part of the punishment and humiliation. A family member could request that his or her relative be allowed to wear underwear supplied by the relative if that prisoner was doing "good time"—in other words, there were no infractions against him and no meted-out punishments. The warden would grant such permission (particularly if a sizeable payment came with the request). So, some of the more well-to-do inmates enjoyed the luxury of underwear.

The reek was unimaginable: the stench of the lidless honey buckets; the sweating, filthy inmates who were bathed every two weeks; their clothes, laundered and changed likewise. This was compounded by the lack of circulating air (there were no fans or windows, except for those at the front walkway). Often, the guards, on entering, would gag or throw up. Disease spread rampantly. Dysentery, cholera, syphilis and tuberculosis took hundreds of lives. If an inmate had a red mark on him, terror spread with the fear that he may have measles. If so, an epidemic could prove devastating, as the disease could cause death, blindness, deafness or a life of incapacitation. Even the guards lived in terror of a measles outbreak.

Construction of the West Wing began in 1842, after the capture of the Jackson Robber Gang, and was completed in 1848. In less than ten years, the facility became overcrowded, and inmates were lined up in cots against the front wall. The building of the West End Wing began. This edifice, four galleries high, contained three hundred cells. These cells would be longer and narrower than those in the West Wing: three and a half feet wide by six and a half feet long by seven feet high. These would be the dimensions of all future cells until the building of the East End Wing, the final section at MSP, which would feature dormitory-like cells housing six men, or twelve when it, too, grew overcrowded.

The West End Wing, like the West Wing, soon grew overcrowded as the prisoner population increased. Another annex was built and housed four hundred more prisoners. The prison, initially designed to house a maximum of eight hundred inmates, now had over nine hundred, with the inmate population continuing to grow.

In this era of the big house, wardens had to live on the prison grounds, since there was yet no means to contact them or bring them quickly enough to the facility in the event of an uprising. The position of warden, a highly political appointment, usually went to the person who contributed the largest sum of money to a senatorial or gubernatorial campaign. The appointee lived in a mansion on the prison grounds with his wife and children.

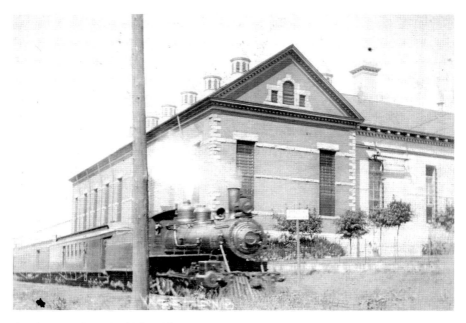

A train passes West End Wing. The author's apartment is at the first window in the center facing the train. Trees now surround the building. The train still goes by. *Courtesy of Jackson District Library.*

In the early 1850s, an up-and-coming architect named Elijah E. Meyers was hired to design the MSP Administration Building. The structure's first floor would house the reception area, where prisoners could receive visitors. The second floor would contain administrative offices, and the third and fourth floors would provide the spacious home of the warden and his family. The fifth floor would serve as a place to hold parties and political events.

Meyers became the leading architect of capitol buildings throughout the nation, including those in Lansing, Michigan; Tulsa, Oklahoma; Olympia, Washington; and many other cities throughout the United States. He also designed several buildings in Europe and churches in America, including the stone Methodist church on North Capitol Avenue in Lansing. His signature item for capitols and also featured on the prison was a cupola representing the large head of a bird of freedom, such as an eagle. The roof under the cupola slanted downward and represented the flapping wings of a bird of freedom. It goes without saying that those incarcerated in the small, ventilation-less quarters in the cellblocks dreamed of having those wings of freedom. As the prison grew, its majestic outside belied the conditions inside.

In this era, each city granted the privilege of housing a penitentiary could pick its own style of architecture for these grand structures. Jackson chose Greco-Roman. In contrast, for example, Mansfield, Ohio's reformatory resembled a huge German castle, and later, the Ionia Reformatory in Michigan featured the architecture of a Roman villa.

By 1861, the entire west complex of MSP was completed. And, again, overcrowding became a problem. The East Wing was added on the east side of the grand Administration Building. Soon, it was teeming with too many inmates, and the East End Wing was constructed. All the while, convict laborers built the prison wall surrounding the house of incarceration. The wall was fourteen feet high and made of stone, sandstone and granite. This height, however, proved inadequate, as escapes were still possible. The wall's height was increased to twenty-five feet. A walled prison of this era traditionally has buildings as its front wall. The West End, West Wing, Administration Building, East Wing and East End Wing constituted the front wall. Three walls met this front wall at the back end of the East End Wing and at the back end of the West End Wing.

Factories were built within the prison walls. Tunnels ran under the prison grounds and under Mechanic Street. The tunnels were excavated and lined with brick by the inmate labor. These tunnels stood four to

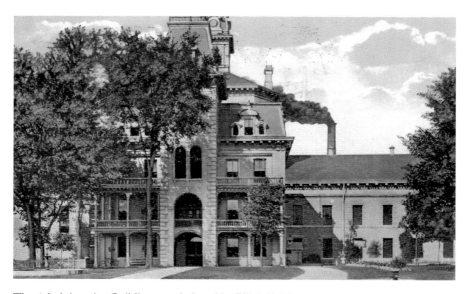

The Administration Building was designed by Elijah E. Meyers, leading architect of capitol buildings, including the one in Lansing, Michigan. *Courtesy of Jackson District Library.*

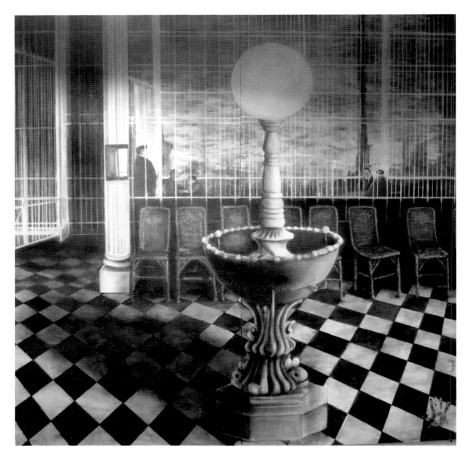

In the visiting area, the fountain, wicker chairs and parquet floor were all made and laid by inmates. *Author's collection. Photographer, Jon Tulloch; muralists, Hector Trujillo and Jean Weir; historian, Judy Gail Krasnow.*

five feet high. Through these, the guards, bending low, marched to their guard towers or to the iron prison gates. If an inmate attempted to escape through the tunnels, he couldn't run, for he, too, would have to bend as he moved. Furthermore, he would end up at the guard tower or at a gate, facing an armed guard.

By 1882, MSP was the largest walled prison in the world, housing nearly two thousand prisoners. Its factories turned out binder twine, monuments, tombstones, fabric, machine parts, chairs and other furniture. The prison had a tailor shop, a sausage factory and a canning facility that became world-famous. Likewise, its very first factory, the Jackson Wagon Factory, also known

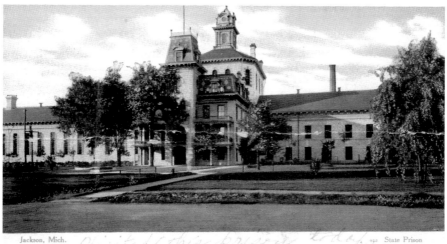

Jackson, Mich.

Visited this prison today. Very nice place. All well. love + kisses Rose.

State Prison

Above: This postcard shows the West Wing, Administration Building and East Wing of the prison. It includes a written message. *Courtesy of the Jackson District Library.*

Right: West End Wing, West Wing Annex and factories are shown as the excavation and construction of the huge labyrinth of tunnels continues. *Courtesy of Jackson Historic Prison Tours.*

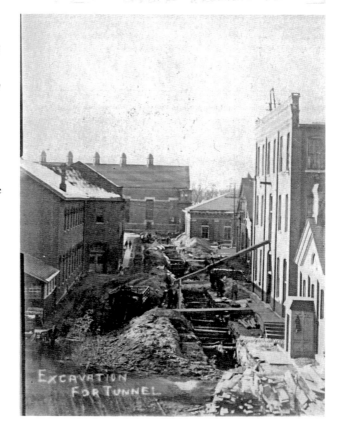

EXCAVATION FOR TUNNEL

The West Tower and twenty-five-foot prison wall are seen here. Guards could only enter the towers via tunnels running beneath the prison grounds. *Courtesy of Hector Trujillo.*

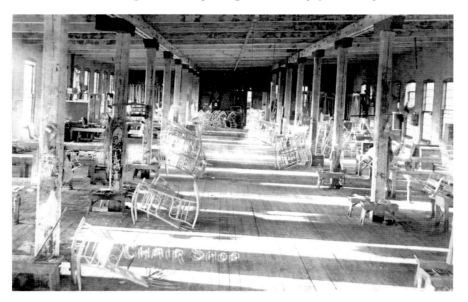

Inmates at the chair factory made, among other things, the wicker chairs that lined the visitation room. Chairs produced at the factory were sold in the downtown's Prison Store. *Courtesy of Jackson District Library.*

State Prison Farm & Prison, Jackson, Mich.

The prison's farms stretched for three miles. Only low-growing plants, such as beans and melons, were farmed, so that prisoners were in view at all times. *Courtesy of Jackson District Library.*

as the Austin, Tomlinson, Webster Factory, gained renown. Three miles of farmland stretched along North, Cooper and Loomis Streets. The prison was Jackson's largest employer, a big moneymaker for the state, and proved totally self-sufficient in producing its food as well as food and goods to be shipped throughout the surrounding areas and to other states. Its vineyards were harvested, and the prison manufactured popular wines. Michigan's first state prison turned Jackson into the third-largest city in the state during its time and into one of the leading industrial cities in the nation.

BREAKING ONE'S SPIRIT

Punishments and a New Law

Life behind bars in what came to be called "Jacktown" was anything but pleasant. Cramped cells; insufficient ventilation; lack of heat, electricity and plumbing; and forced labor constituted an existence that authorities believed would stop those who had committed crimes from repeating such mistakes. Punishments were meted out with the belief that no one receiving them would wish to come back for more.

Every person admitted to the prison spent the first fourteen days in solitary confinement to "break his spirit." Solitary consisted of cells with no trace of light, only a brick floor on which to sleep and, in the most punitive cells, no honey bucket. The inmate slept, sat and ate next to a trench used as a toilet. Through a very small opening from the outside, water would be sprayed in to wipe out the contents of the trench. Special suits were worn by convicts while in solitary, designed to minimize the possibility that any of its pieces could be used to attempt suicide. These suits were seldom laundered. What one man wore during his confinement was simply passed on to another to wear, including the sweat, excretion and vomit.

While confined in solitary, a prisoner was given water in a flask-like container called a "gill." It contained a quarter of a pint of water. If one ran out of water or was feverish and parched, he could scream, rant and yell, but he would not receive more until the twenty-four hours were up. The doors to the cells were solid oak, with a little round window for a guard to look through and slits wide enough to insert bread and the gill. Iron bars stood behind the oak door on the prisoner's side. When a man was

Four floors of solitary confinement included a literal dungeon on the basement level. Sixteen vermin-infested cells stood outside the back of the West Wing cellblock. Many convicts confined there went insane. *Courtesy of Jackson Historic Prison Tours.*

to be released from solitary, his state of mind and temper were not known. The guards needed to assess whether or not the inmate would lash out at them, so they would first observe through the iron bars. If it was deemed safe, they would open the barred door, cuff the man and, if necessary, shackle his legs with chains.

The initial fourteen days of solitary confinement broke some spirits. It enraged others. Convicts placed in solitary for infractions were sometimes confined there for two to three months, some longer. An inmate named William Walker, serving a life sentence, told his story to author Thomas S. Gaines in a book, *Buried Alive (Behind Prison Walls) for a Quarter of a Century*. Though illiterate, he vividly describes solitary as a place where "passion feeds upon the heart… consumes the mind, dwarfs the brain, destroys the intellect, and leaves a man a total wreck."

He tells of lying on a hard floor or rickety cot "alive with vermin." He likens the cells to hog pens, where "bugs and insects were in their glee." The only light and ventilation in solitary was a hole twelve inches long and two inches wide, cut on a slant through the top of the cell door. In order to see any light, the inmate had to lie on the stone floor and look straight up. Walker spoke of the many deaths that occurred, after which the inmates were buried in the prison's actual hog pen, where the prison cemetery stood.

The bread-and-water diet was not a myth. For those prisoners confined to solitary in the 1800s, it was a fact. There were many suicides in spite of the clothing designed to prevent them. Banging one's head against the brick or concrete walls sufficed. Screams could be heard echoing throughout the cellblock, and if one was not insane going in, chances of being so upon coming out were high.

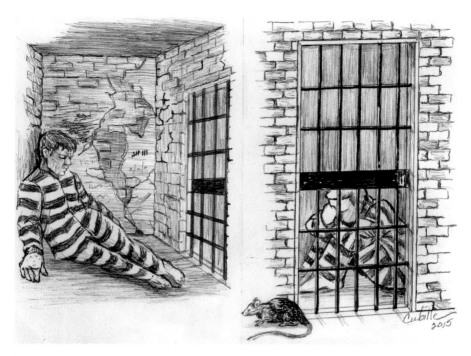

Solitary confinement caused many inmates to go crazy or attempt suicide. They suffered malnutrition and impaired eyesight from prolonged darkness. *Author's collection. Illustration, Armory Arts Village artist Louis Cubille.*

On May 18, 1846, Michigan did something politically that no other state had done at the time: it abolished capital punishment. Since its admission to the Union, Michigan stands out as one of the few states never to have executed anyone. The state also set the precedent as the first English-speaking government in the entire world to totally do away with the death penalty for ordinary crimes—those excluding treason, espionage and piracy that inflicts violence. Murder, robbery, kidnapping and even rape would be considered ordinary crimes. Michigan did retain the death penalty for treason until 1963. However, no person in the state has ever been tried for treason against the state, and therefore, no state executions occurred since the passage of the law and, in actuality, since Michigan attained statehood in 1837. All executions in areas now within the state of Michigan took place prior to the achievement of statehood on January 26, 1837.

Between 1683 and 1836, approximately fifteen executions were reported. Prior to 1783, the area of the future state was under French, then British, control. During this time, there were cases in which persons convicted

of committing a capital crime in Detroit were removed to Montreal for both their trial and execution. An execution did take place in the Federal Correctional Institution near Milan in 1938. Anthony Chebatoris was hanged for a murder committed while robbing a bank in Midland. Most of the executions between 1683 and 1836 were accomplished by hanging, although two people were shot, another was bludgeoned and yet another was executed by a means that today remains a mystery. (The accompanying chart lists those executed during those early years. It denotes their name, crime, date and method of execution and race.)

NAME	DATE OF EXECUTION	CRIME	METHOD	RACE
FRENCH JURISDICTION				
Folle-Avoine	November 29, 1683	Murder	Shot	Native American
Unknown	November 29, 1683	Murder	Shot	Native American
Pierre Berge (or Boucher) dit La Tulipe	November 26, 1705	Assault	Hanging	White
Bartellemy Pichon dit La Roze	November 7, 1707	Desertion	Hanging	White
BRITISH JURISDICTION				
Unknown female slave (owner's name, Clapham)	April 1763	Murder	Hanging	Native American
Michael Dué	Late 1760s	Murder	Hanging	White
Joseph Hecker	December 1775	Murder	Hanging	White
Jean Baptiste Contincineau	March 26, 1777	Robbery	Hanging	White
Ann Wyley (or Wiley)	March 26, 1777	Robbery	Hanging	Black
Buhnah	1819	Murder	Unknown method	Native American
Ketauka	December 27, 1827	Murder	Hanging	Native American

NAME	DATE OF EXECUTION	CRIME	METHOD	RACE
Kewaubis	December 27, 1827	Murder	Hanging	Native American
James Brown	February 1, 1830	Murder	Hanging	White
Stephens Simmons	September 24, 1830	Murder	Hanging	White
Wau-Bau-Ne-Me-Mee	July 1836	Murder	Hanging	Native American

While Michigan's 1846 abolition of capital punishment was motivated by good intentions and was considered a humane action, the punishment that replaced it ultimately proved far more brutal. It would be fifteen years before the end of the death penalty became truly humane. The 1846 law meant that those who would have been condemned to execution would now be condemned to life in prison—in solitary confinement! Twenty inmates in this situation were locked behind the bars of Michigan's first state prison. They were thrown into the dark, dank cells lacking ventilation and light. Their diet consisted of bread and water, with a meal of meat and potatoes twice a week. These inmates were allowed no human communication and no visits from family or friends. They were like caged, neglected animals. Fresh air, sky, clouds, rain, wind, snow and sun would be gone from their lives forever.

In September 1861, state inspectors arrived to do their quarterly round of checks. By that year, the entire West Complex of the growing prison was complete. The agenda for the officials consisted of inspecting each cell, including all of the solitary cells. When the cells of the twenty inmates condemned to life in solitary confinement were opened, the inspectors were utterly horrified.

All twenty were blind, as their eyes had seen no light for fifteen years. Their hair had grown long and was matted and infested with lice. They were covered with cockroaches. Their skin, dry and shriveled, oozed with sores of malnutrition and neglect. Any fingernails and toenails not bitten or chewed to the bone had grown into winding claws. All of the convicts suffered from virtually every form of malnutrition. Nine could no longer speak, but only grunt, and they necessitated commitment to the state mental asylum. Six, dreadfully ill, died when exposed to sunlight while being carried to the infirmary. The remaining five were hopelessly

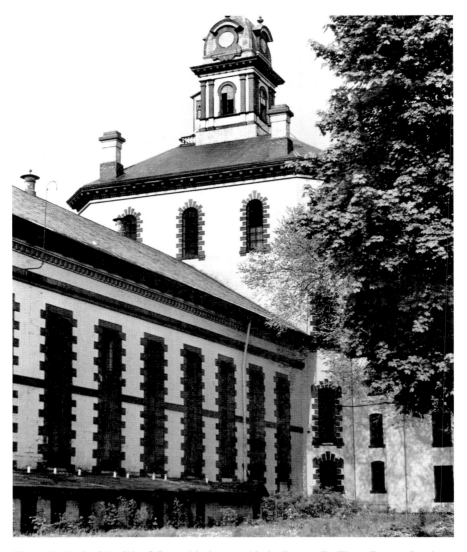

This is the back of the West Wing, with sixteen added solitary cells. The cells were freezing in winter and broiling in summer. *Courtesy of Jackson District Library.*

crippled and blind and would spend the rest of their lives as indigents, whether in or out of prison.

The inspectors appealed to the state legislature to reinstate capital punishment. "It is more humane to hang a man than for a man to live as these twenty have suffered for fifteen years. There is no crime, no matter how heinous, that warrants such punishment as this," they implored.

The legislature did not repeal the law against capital punishment. Instead, the law was changed to read that a man could be condemned to life in prison but no longer life in solitary confinement. The term "lifer" originated at MSP. To date, though several votes have been taken, the people of Michigan, whose referendum could change the law, have chosen not to reinstate capital punishment.

OTHER PUNISHMENTS

Silence!—The Code of Silence

A federal law applied to all penitentiaries established in the growing number of states: the Code of Silence. Prisoners were not allowed to talk unless spoken to by a guard, a foreman in a factory or a person of authority who engaged them in conversation. A convict was not to talk to other inmates in the cellblock or even talk or sing to himself. Silence was required while walking lockstep to the mess hall and during meals. Since humans possess the gift of speech and are considered "social animals," this particular law proved extremely difficult to abide by. But the punishment for violating it was severe.

The convict who spoke out of turn had his wrists chained together. An iron hook was inserted under the chain, and the man was hoisted up, arms above his head, hands entwined in chains and feet four to five inches off the ground. He was left hanging in this painful position for between five and seventy-two hours, depending on the severity of his infraction. Breaking the Code of Silence not only resulted in excruciating physical punishment that damaged rotator cuffs, arms, wrists and other parts of the body. It also could prove a genuine hindrance to an inmate's livelihood.

In the prison factories, quotas had to be fulfilled. A convict in the leather factory making shoes had to produce six pairs in the twelve- to fourteen-hour workday. If he ran out of nails, wood or leather, he needed to raise his hand until the foreman noticed him. Often, the foreman was at the other end of the huge industrial room with his back turned from the workers. Ten minutes may pass, or twenty or thirty. The convict was losing time and was in jeopardy of not fulfilling his quota. Desperate, the man might call out amid the whirring of machines: "Excuse me, Mr. Foreman. I need more nails." Wrong choice! For calling out in his attempt to fulfill his daily quota and do his job, an inmate could be punished by a dock in pay, a whipping or by being chalked in. Chalking in required a guard to draw a large X with

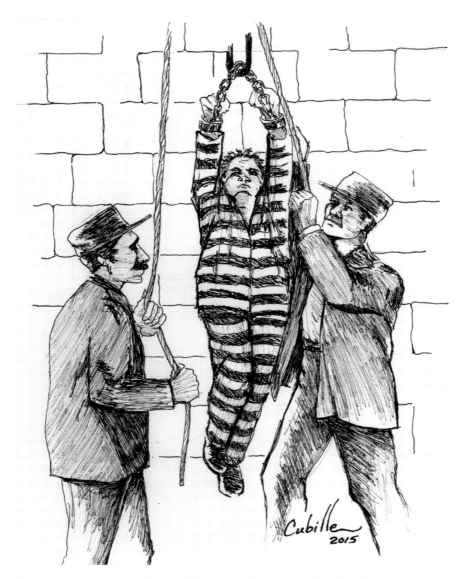

Prisoners who violated the Code of Silence were hoisted with their feet off the ground for between five and seventy-two hours. *Author's collection. Illustration, Armory Arts Village artist Louis Cubille.*

chalk at the top of the inmate's cell. The chalked-in prisoner had to remain in his cell for a full twenty-four hours, sometimes for several days. Often, chalking in meant no food. If it was shower day, it could mean not being showered and not being allowed to empty one's honey bucket.

I've Got You Over a Barrel: The Bat

The saying "I've got you over a barrel" derives from a prison punishment. An inmate would be stripped down to his undershorts (or given a pair to wear when underwear wasn't allowed). A huge wooden barrel stood next to a post. The prisoner bent over the barrel. With his arms lifted and wrists crossed, his hands were tied to the post. With the warden and/ or deputy warden standing by, an assigned guard would take a paddle, called "the bat," and whip the prisoner. The paddle often had a strip of leather on its top so that the convict could be paddled and whipped simultaneously. This punishment was not permitted to take place without the presence of a physician to ensure that death didn't occur. As long as the physician supervised, the prisoner could be whipped as many times as his body could withstand it.

The resulting blistering from the beating caused infection. In an attempt to prevent infection caused by the injurious paddling, the bat was soaked in a salty brine solution. The salt was now paddled onto

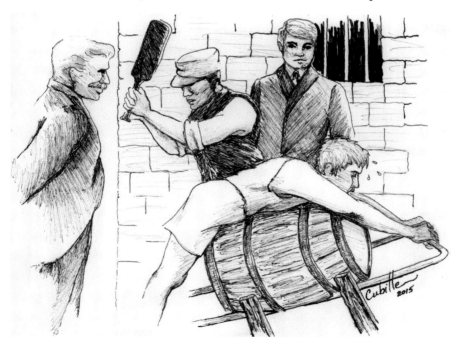

"I've got you over a barrel." An attending physician would say "Stop" when an inmate beaten with a bat had enough. *Author's collection. Illustration, Armory Arts Village artist Louis Cubille.*

flesh suffering lacerations from the bat and its whip. It was excruciating. Furthermore, it did not serve its purpose. Infection continued. Ultimately, a sheet heavily soaked with the brine solution was placed on the inmate's back and the paddling done over the sheet. Open wounds still occurred, and the salt in them may have lessened infection but not the severity of stinging and pain.

The Iron Cap

The "iron cap" resembled a birdcage. Made of iron, it weighed a fair amount as it sat on a prisoner's shoulders, pressing on the collarbone. It had an iron neckband that was locked and felt like an iron turtleneck garment. The iron cap was worn for a minimum of fourteen days. The prisoner being punished in this fashion had to eat, sleep and work with the heavy piece of iron on. This punishment, applied for infractions such as being discovered with a shiv (improvised weapon), having spoken threateningly about an authority or brawling with another inmate, was considered one of the most humiliating. Everyone knew that the inmate wearing it had earned some very bad time. Inmates, as is well known, enjoy scapegoating another inmate who has slipped up.

The heavy iron cap, worn for between fourteen and thirty days, caused damage to the shoulders and collarbone. *Author's collection. Illustration, Armory Arts Village artist Louis Cubille.*

Whippings, Chalking, Segregation

In 1826, Michigan outlawed the use of the ox whip for punishing prisoners. However, whipping with a weaker leather whip was considered acceptable. The inmate could be whipped until he finally apologized and vowed never to misbehave again.

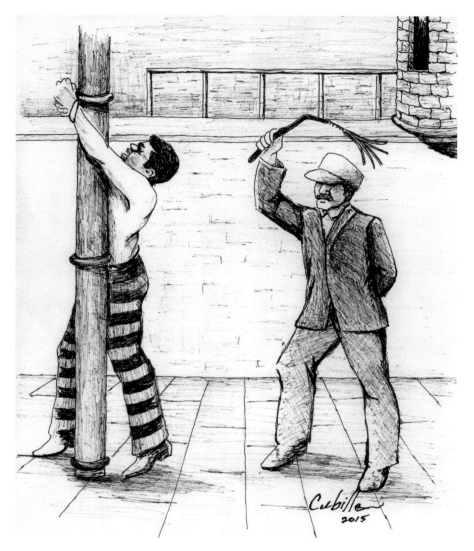

Whipping was a common punishment in the 1800s and early 1900s. It could result in permanent physical damage. *Author's collection. Illustration, Armory Arts Village artist Louis Cubille.*

Chalking, as stated above, meant placing a chalk mark above the cell of an inmate who refused to behave inside or outside his cell or who cajoled a guard into coming to the cell under the guise of feeling ill and then urinating or spitting on the guard. A man chalked in often had no food or, as in solitary, a diet of stale bread and water. He could not leave the cell to carry his honey

bucket for cleaning at the bucket grounds. The bucket often overflowed, making his cramped cell even more foul-smelling and filthier. Locked in with nothing to do and having to remain silent could drive a man mad. Many men did indeed suffer this fate.

Segregation entailed separating an inmate who was dangerous to others or who was endangered by other inmates in a cell from which he was not allowed to leave. Food was slipped through the bars. This differed from solitary confinement, which was a harsh but temporary punishment. Being segregated meant just that: being kept apart and away from those who could suffer harm from the offending inmate's dangerous actions, or vice versa.

Whatever the punishment, more often than not, the inmate suffered permanent physical scarring and maiming that would impair or cripple him for life. This was not conducive to rehabilitation and release as a healthy, functioning citizen.

A Sadistic Reign with a Just Ending

Agent John Morris

In 1870, the head administrator and director of a prison held the title of agent, not warden. It wasn't until 1880 that this title changed. Initially, in a penitentiary, the agent contracted factory owners to establish their factories within the prison walls. In 1880, this contracting became the responsibility of the state. Agents, like wardens, were a highly political appointment based on contributions to senatorial and gubernatorial campaigns, large donations to local churches and, generally, being a prominent citizen with money and stature.

In Jackson, John Morris was one such person. His outer demeanor was gentle and kind. In 1868, Henry Porter Baldwin was elected governor of Michigan, serving from 1869 to 1873. He appointed John Morris agent of MSP. (Baldwin, while governor, vetoed the Women's Suffrage Amendment, which was passed in the Michigan legislature in 1870.) His appointment of Morris drew some criticism, as those who knew John Morris feared he was too kind and gentle to dispense the firm discipline that the job required. Little did those acquainted with Morris know that under the seemingly peaceful, gentle gestures and warm smile of a Dr. Jekyll lay a Mr. Hyde.

As if there weren't enough brutal punishments, Morris initiated some of his own. Borrowing a very painful torture method used during the Civil War on prisoners of war who refused to talk or soldiers who went AWOL, John Morris utilized the "wooden horse." This punishment, called "riding the mare," was a favorite of Morris. To this torturous treatment he subjected prisoners whose looks he simply didn't like or who irked him, as

well as those who had engaged in bad behavior. The device, resembling a builder's sawhorse, consisted of four legs on which a triangular saddle-like piece was placed. A two-inch piece of sharp, splintered wood formed the top of the "saddle." The wooden horse stood eight feet high. On it a prisoner was hoisted, hands cuffed behind him, weights on his ankles, to sit on the sharp, two-inch board. In snow, sleet or hail, rain or broiling sun, the prisoner sat "riding the mare" for a full eight hours. The poor inmate sat in pain, unable to move, unable to drink water, eat or excrete. Two inmates who had engaged in a fight would be placed on the device with not only their hands tied behind their backs but also with their heads strapped together, forehead to forehead.

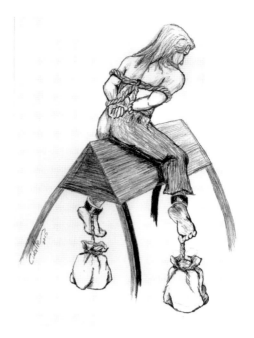

"Riding the mare." An inmate sat on this device in sun, sleet or rain for eight hours. *Author's collection. Illustration, Armory Arts Village artist Louis Cubille.*

Another favorite technique of agent Morris was to strip a prisoner, no matter the weather, and chain him to the iron gate outside of the West End Wing. Morris would attach a hose to a nearby fire hydrant—or more often than not stand by while he ordered a guard to do so. The width of the nozzle attached to the hose varied in accordance with the level of pain Morris wished to inflict. The poor victim would be the subject of the powerful spray of cold water, often compared by those who suffered it to millions of needles pricking the skin. The subject would undergo this torment for anywhere between ten and fifty minutes. When the screams and pleas for mercy and apologies sounded genuine enough to Morris's ears, he would halt the treatment. The victim, shivering and black and blue all over, incapacitated, would then spend two to five days in the infirmary.

Perhaps the worst of the punishments that can only be called tortures, both for its symbolism and the effects it had on the bodies of those subjected to it, was the cross. Constructed by Morris, it resembled nothing less than

the cross on which the Romans hanged people, including, of course, Jesus. In the dungeon of solitary confinement, Morris's victims would be tied to the cross by the wrists and ankles with raw, wet leather. As the man hung there, the leather dried, tightening and cutting off circulation. He would hang there for days, unfed and without water.

How could such a sadist persist? Why didn't the guards, night keepers, hall keepers or other prisoners report these atrocities? How does any cruel and inhumane dictator gain and hold such power? For one thing, if a prisoner did speak out or write to the legislature, his letter would be intercepted and read by the agent. This prisoner would thus most likely subject himself to severe punishment. Doctors who complained were fired on the spot, as were guards who refused to carry out Morris's punishments or dared to speak out. A reign of silent terror cast its pall over Michigan's first state prison. In his book *Becoming Evil*, James Waller writes:

> *I define human evil as the deliberate harming of humans by other humans. This definition of human evil includes the creation of conditions that materially or psychologically destroy or diminish people's quality of life—their dignity, happiness, and capacity to fulfill basic material needs. Such conditions include…psychological harm from threat of physical injury, trauma, or fright…exploitation, debasement.*

He also writes about how persons can do things that they would never consider doing individually, sidestepping personal responsibility for "diffusion of responsibility" when group expectations are involved. Personal blame can be diverted to the group's wishes and demands. In the case of John Morris and his reign, the guards were forced to inflict punishments on the inmates. The doctors had to be in attendance and watch as an inmate was obviously being severely disfigured. Managers closed their eyes to the pain and injuries of the prisoners working in their factories; they could lose their jobs if they complained or reported the goings-on. The expectation that prison and punishment went hand-in-hand meant that many persons put aside their personal horror at what Morris was inflicting and accepted it in the name of the institution. That is, until the outright brutality of the beating of Drayton Thurston, the virtual loss of an arm to a prisoner who had sustained an injury to that arm during the Civil War and the death of a man punished by submergence in icy water. These actions led to the end of Morris's sadistic rule.

In secret, some off-duty guards who lived in Adrian, Michigan, approached a news reporter there. They spoke of some of the horrors they'd witnessed in their jobs. The reporter decided to go see for himself. He professed to Morris and other officials that he'd heard how well they ran the prison, how good the medical care was and how productive the factories were. He said that he wished to write an article and let the public know. Privately, he asked the inmates, guards, doctors and factory foremen what was going on at the prison. At their wits' end of the five-year reign of terror, they all talked. They looked around to make sure no one was listening. To make sure suspicion didn't arise during these interviews, they took on a friendly stance and body language that belied the horrific truths their mouths were uttering. Reality unfolded. The result was a shocking article that resulted in a state investigation and trial.

STATE PRISON INVESTIGATION OF AGENT JOHN MORRIS

In the *State Prison Investigation of Agent John Morris Preliminary Proceedings in the House and Senate* is the following statement:

> *Whereas,* The Daily Press, *a newspaper printed and published in the city of Adrian, Lenawee county in this State, charges in its daily edition of the 27th and 29th instant that John Morris and his subordinates in charge of the State Prison at Jackson have practiced extreme cruelty upon the convicts in said prison; "that about nine months since a convict therein was strung up by the thumbs for 24 hours, and in consequences thereof is now a cripple for life;" "that another convict was taken out into the yard and plunged into cold water, and died before they got him out;" "that on Friday, the 19th instant, a convict over the age of sixty years was stripped and strung up to a post and received 25 lashes upon his bare back, from which he is now in the hospital of said prison;" therefore,*
>
> *Resolved, (the House concurring), That the committees of the Senate and House upon the State Prison be instructed to investigate the said charges be investigated…and without secrecy and with doors open to the public.*

Testimonies came from anyone and everyone in the prison's hierarchy, from guards and night keepers to hall keepers and doctors. Even convicts

were invited to provide accounts. George Cook, a hall keeper, provided this information:

> *Q. Who inflicted the punishment?*
> *A. Mr. Morris, the Agent.*
> *Q. Describe the whip.*
> *A. Well, it was a common horse whip....The end of the lash was part buckskin, or calfskin braided on the lash.*
> *Q. How was the convict?*
> *A. His hands were tied together, and he was tied up, drawn up to a railing to the first gallery....*
> *Q. Was he stripped?*
> *A. Yes....Most of the flogging was about his breast and shoulders, perhaps some down as low as his body....He was tied up, so there was nothing to prevent his being whipped round his person.*
> *Q. Do you know how many lashes he received [in] the first whipping?*
> *A. Seventy-four.*
> *Q. Who inflicted the second whipping?*
> *A. The Agent, Mr. Morris....Instead of being tied up so the whip would go clear around him, he was tied up to the side of the post.*
> *Q. Do you know how many blows he received?*
> *A. I counted over ninety....There was considerable talk among keepers; some thought he struck him over a hundred.*
> *Q. What effect had these lashes upon his person?*
> *A. Well, they cut him pretty bad in places.*

In a testimony that takes up several pages in the investigation, A.A. Bliss, a prison inspector, answers questions about the wire cap. "They are a cap made with the meshes, perhaps half an inch a-part, and there is a band round the bottom that opens, and is put around the neck loosely, and locked, and this covers the whole head." Of the wooden horse, he says, "I find a punishment of riding a wooden horse—two men face to face."

Deputy keeper George Winans, now sworn in, described the hosing:

> *The convict would be stripped entirely naked. The nozzle would be held six to twelve feet from the prisoner. Their hands were tied to their back with a half-inch rope. They were fastened to a door. They were showered on all parts of their body....I have seen men whipped and tied up by their hands in a bare cell.*

Bliss described the problems of prison discipline:

The discipline of the prison is considered absolutely essential to the safety of all.... There are men who have been overcome by their passions at particular times, and have committed crimes that they ever after regretted. They are well-behaved men, and are never subject to discipline.... There are others, men who have committed a few crimes, who have been suddenly overcome by temptation. When they come there they see the folly of their course and have no disposition to disregard the rules. There is another class who get there because it is their business to commit crime. They are defiant towards the authorities and determined to have their own way. When their sentence is out they will go out and commit crime the first opportunity they have. That is the class of men that make nearly all the trouble in the prison.... The more I have seen of prisoners the more I have been convinced that there is a class of convicts who cannot be governed in any other way than by some sort of punishment of that kind....I will say this: that punishment is exceedingly repugnant to our feelings, and I have long felt that if it were possible to substitute anything else for it, and the discipline of the prison be preserved, it would meet my hearty approval.

Yet others offered descriptions of scenes they had witnessed:

I have seen them showered (with the hose) until they were black.

Mr. Morris favored upper class prisoners. He allowed them to have tobacco. I think the making of tobacco in the prison causes most problems. He let 74 prisoners have it along with starched shirts and collars and an extra suit of clothes and pants.

There were no rules for good behavior other than the rules of the Agent.

James L. Perkins, a fifty-year-old lawyer from Jackson who had served time for forgery, testified to the following:

In the north hall of the West Wing, I saw Mr. Morris and two or three others going in at the lower door; they were taking a prisoner with them; it was but a few minutes after that I heard him scream and heard the instrument, whatever it was, a lash or strap some said it was, being applied to him, and I heard his screams...some others were cleaning up where the excrement run from him during the whipping...

> *I have seen Mr. Morris when men were screaming during hosing, tell them to shut up, and direct it right into their mouth, and hold it there until they would be almost completely drowned down, so that they could not make a noise, and then direct it to some other part. They were fastened with their arms stretched out to the door and a strap under the chin, fast.*

A question by an interrogator reads as follows:

> *Q: Did you ever know of anything that in your judgment was injurious or detrimental to the discipline of the prison, in which women were concerned in or about the prison?*
> *A: I have been informed that certain officers connected with the administration of the prison have, in some instances, made use of their official position with female relatives of the convicts, to solicit improper favors.*

Dr. J.B. Tuttle, called upon to testify as to the "comforts" of the prisoners, stated that they hadn't sufficient blankets or heat and that the ventilation in the cellblocks housing two hundred to three hundred men was not sufficient. The fact that they were not permitted to wear undershorts or undershirts aggravated the situation, for in the cold weather, they had no garment to cling closely to their bodies to keep drafts from penetrating their clothing. He claimed that the straw mattress ticks were too thin for a restful night's sleep. Tuttle's most revealing testimony concerned the mentally ill, who belonged in asylums, not in prison, where they were locked in small cells and not allowed out, even for fresh air. He offered the following opinion:

> *In the first place, I would have the asylum surrounded by a wall so that they could be let out into a yard, and not be liable to escape, so they could treat them with some degree of humanity. Pretty much so, they are now confined in a cell. I do not know but there is one or two that have liberty to go out into the hall. Some of them are not vicious, but as a general thing, they are enclosed in a solitary cell.*

THE BEATING OF DRAYTON THURSTON

Drayton Thurston combined a sharp wit with an independent spirit and a sense of justice. These traits make for a difficult prisoner. The injustices he witnessed upset his notion of fair play and riled his quick temper. Rumor

spread that he wanted to stab agent Morris. An investigation began within the prison walls about whether anyone had seen Thurston creating a weapon. Eventually, a pipe sharpened at the edges into a knife was found in a metal box. Morris personally beat Thurston with the outlawed ox whip sixty-three times. The next day at Thurston's job in the cigar factory, the foreman noticed Thurston acting jumpy and unable to sit down or concentrate on his work. Suspecting what may have happened, he asked Thurston why he couldn't sit and why his hands were shaking so violently. Thurston pulled down his pants and lifted his shirt, both of which stuck to the dried blood of his lash wounds. The foreman had it. At the risk of being fired, he reported this beating to the reporter from Adrian, where the foreman resided.

THE TRUE TALE OF WILLIAM McDONALD

When the reporter from Adrian visited the prison, among the information he acquired, he heard the story of William McDonald's severe punishment and its woeful result. This information was repeated in great detail in the interrogation by the Michigan congressional panel. McDonald, thirty-three, came to America at age four or five from Galway, Ireland, and lived in Springfield, Massachusetts, until, at age fourteen, he joined the crew of a ship sailing northern rivers and the Great Lakes. This seafaring adventure took him into the world of smuggling, at various times for the British, the French and the Americans.

During the Civil War, McDonald joined several different Union regiments, from the North all the way down to Louisiana, remaining with each one just long enough to get his first payment of anywhere from $50 to $200. He'd then desert the regiment, travel far away where he could not be found and start a business. These ranged from carpentry to running a yacht purchased with the help of a British smuggler and finally to becoming a butcher. In this latter profession, McDonald was arrested and convicted of stealing three cows and butchering them. He got five years in the Columbus, Ohio penitentiary for burglary. He was released after three years for doing good time and found work smuggling on Lake Erie. The goods with which he was found sent him to MSP with a fifteen-year sentence.

At MSP, like so many other inmates, he developed "the bloody diarrhea" from the dreadful prison conditions. Sent to the infirmary

and tired of his long stay there, he managed to slip out to hear a musical performance in the mess hall. His intention was to return to the hospital quarters. Unfortunately, agent Morris spotted him. McDonald was one of the inmates whom the agent had decided right off the bat that he didn't particularly like. He insisted that McDonald return, not to the infirmary, but to the cigar shop where he worked.

Weak and unable to produce his daily quota—according to another inmate's account, McDonald came up short of his quota by twenty-two cigars—McDonald, rather than being returned to the infirmary where he belonged, was sent by Morris to solitary. Morris tied him up on the cross. In his short stay with a Michigan regiment during the Civil War, McDonald had received a bullet wound in his left arm. Using the wet leather that would soon dry tight, Morris bound McDonald's arms to the cross, double-wrapping the leather around his formerly injured left arm. In his testimony, McDonald described the "misery, where tingling began, then total numbness as though I had no arms at all." He was strung this way for three days and taken down only to eat lunch on each of those days. When released, he could barely stand and was pushed into the railing of the walkway while being returned to his cell. Having no feeling in his arms, he could not catch himself, and but for being caught by a guard, a Mr. Martin, McDonald would have fallen to serious injury or his death.

For the next two years, McDonald's left arm smelled so putrid that he had to wait until all prisoners left the huge mess hall before he went in. He was forced to eat alone. No one wanted a cell near his. Guards gagged when near him. Carbolic acid was applied to the rancid-smelling arm through a device that resembled a brush but had needles instead of bristles. The doctor had no idea what was wrong, even as the arm alternately turned blue and green. When Dr. Tuttle arrived at the prison, he had, of all people, Drayton Thurston care for William McDonald, as Thurston knew how to treat major wounds of this nature. For months, with Thurston's applications of potash and lye, chunks of flesh poured out of open wounds in McDonald's arm. Eventually, his left shoulder withered, as did his arm, which became useless. Yet Morris insisted he continue working in the cigar factory, where he could not efficiently meet any quota. As a result, he suffered confinement in solitary or whippings.

His obviously useless arm and his consistently repeated story to both the Adrian reporter and the Michigan legislature were the final blow to John Morris, despite the testimony of many upper-echelon prison employees who

spoke of Morris's upright character and testified that he was simply trying to run a well-disciplined prison.

The verdict of the state congress after hearing all the witnesses and their testimony was that John Morris could no longer serve as agent. His punishment would not include imprisonment or fines. He was to leave Jackson and never return. He moved to Texas. What work he took up there remains unknown, but this author conjectures that it may well have been in the harsher corrections system of that state, noted to this day for its numerous executions.

THE NIGHT KEEPER'S ERA

Reports and Reforms of John H. Purves

In 1870, a night keeper who would live on in posterity through published reports of his nightly rounds joined those employed at Michigan's first state prison. John H. Purves, born in Scotland on May 26, 1839—the year MSP opened—came to the United States, and his family settled in Freemont, Ohio, where they farmed, as they had done in Scotland. In 1862, at the age of twenty-three, John enlisted in Company B, Fifty-First Regiment, Ohio Infantry, as a Union soldier. He received a promotion to second lieutenant on November 1, 1864, in Company G of the regiment. A letter from the collection of Bruce McIntosh, John H. Purves's great-grandnephew, reads that he was honorably discharged in November 1865. It continues:

In Stone River, Tennessee, while engaged in battle, he received gunshot wounds in the <u>top of his head</u>, <u>one in his abdomen</u>, <u>one in his left ankle</u> where the ball still remains, <u>one in his left knee</u>, <u>one above the knee in his right leg</u>, and <u>one in his right arm</u>, also at the battle of Chickamauga, Tennessee on the <u>21st day of September 1863</u>, he received a <u>gunshot wound</u> in the <u>right arm</u>, and again at the battle of Lookout Mountain, Tennessee on November 24th 1864 he received a gunshot wound in right arm, that he was treated for the several wounds received in battle at Stone River in General Hospital No. 8 at Nashville Tennessee where he entered January 13th 1863 and remained one month when he was transferred to George Street General Hospital at Cincinnati on the 13th day of February 1863 and remained four months.

Unlike his brother James, who also signed up with an infantry unit and, bearing the flag, was killed on his second day in battle, John H. Purves, in spite of his wounds, lived a long and productive life. He left Freemont, Ohio, and moved to Jackson, Michigan, at age thirty-three and signed up and was hired as a guard at MSP in 1872. Fair-haired, with blue eyes and standing six feet, two inches tall, he had, as it was called, a "gimpy" leg and walked with a thick cane. His military credentials overcame the obstacles his wounds posed in seeking work in a prison. However, as stated in letters from those working under him, on days when one wound or another flared up, he had to be transported to and from work by "hack" (a horse and carriage for hire, a taxi of the time), though he lived less than a mile from the prison and its imposing walls in the house he owned at 602 Blackstone Street. On those days, it was difficult for him to perform his tasks.

At one point, in 1877, he left the prison to open a grocery store at the corner of what are now Wildwood and West Avenues. However, either his venture failed or the "battles" of prison called to him, and he returned to become a night keeper at MSP. His combination of military firmness and genuine compassion soon led him to the promotion of captain of the night keepers. In later years, when he retired and sought his pension, he, like so many veterans of wars today, had trouble getting the compensation he was due and receiving the medical care necessitated by his wounds. He wrote to the Ohio commissioner of pensions on September 20, 1918:

> *All the same it's a queer law that penalizes the soldier who came home broken and crippled....Our lawmakers do some unaccountable things with no common sense or justice in them.*

During his later years, Purves was an active member of the Grand Army of the Republic.

In one of several documents, John Purves writes: "My wife, Helen Frances Purves, Nay Elderkin, was my only marriage. My wife had no husband but me." The couple had three children: Helen Annette Purves (b. April 28, 1868), Charles Wood Purves (b. January 1, 1870) and Maud Melisa Purves (b. December 23, 1872). All were born in Sandusky, Ohio, prior to the family's move to Jackson.

Perhaps because his prison rounds were conducted at night, Purves didn't witness the brutality that went on under agent John Morris during the day. Though a disciplinarian, Purves became known as the first major proponent of prison reform in the state of Michigan. When Morris was found guilty and

John H. Purves was a Civil War hero, captain of the night keepers, first MSP reformer and author of *Night Keeper's Reports 1882. Courtesy of Bruce McIntosh, Purves's great-grandnephew.*

forced to leave Jackson, General William Humphrey took command. In 1880, the title "agent" was changed to "warden" as the contracting of factories passed from the hands of the prison agent to the state.

By 1882, Purves had become captain of the night guards, known as night keepers. It was his duty to write the reports of his nightly rounds and present them to the warden each morning. Purves's accounts of his rounds became legendary, a result of his gift for words, his understanding that resolve is required to run a prison and his empathetic nature. He also had an uncanny ability to read the hearts of others—whether the hearts of genuine scoundrels, good hearts or even "hearts of gold." His nightly reports continued to be published for many years after his death in 1923, in one of the oldest prison publications in the United States, the *Spectator.* As early as 1917, "The Night Keeper's Reports" were read by those running prisons throughout the state. The balance of punishments, rewards, discipline and humane treatment in the administration of a prison has always been and continues to be an issue and a challenge. Purves's journal shed light on this balance.

In 1882, the uniform of a prisoner featured the classic thick, black-and-white stripes. In the late 1890s and early 1900s, this uniform was considered a humiliation that lowered the self-esteem of a prisoner and, therefore, went against the concept of rehabilitation. Wearing the stripes sent a message to those incarcerated that they were nothing short of a "buffoon"—a fool, clown or joker. At the time that John H. Purves was doing his rounds, this was the garb of those under his charge.

In addition to this humiliating garb, punishments now included the following:

1. The Code of Silence, a federal and state law applying to prisons. The punishment for breaking this code continued to be chaining the wrists of

Prisoners pose for a photo outside the West End Wing. The mural is from an archival photo. *Author's collection. Photographer, Jon Tulloch; muralists, Hector Trujillo and Jean Weir; historian, Judy Gail Krasnow.*

the inmate and hoisting him with his feet four to five feet off the ground. He was kept in this position for anywhere between five and seventy-two hours, depending on the infraction—in other words, depending on how, when, where, why and for how long he violated the Code of Silence.

2. *Whippings on bare flesh with the leather bat.*

3. *The iron cap, worn nonstop for between fourteen and thirty days, with injurious effects on the shoulders and collarbone.*

4. *Solitary confinement in total darkness with a straw mat (or no mat) to sleep on and only a diet of bread and water, the water in a flask-like container called a gill that held only four ounces of water to last twenty-four hours.*

5. *A combination of solitary confinement and being strung up by the wrists, feet off the ground.*

6. *Dousing with a bucket of cold water.*

7. *Withholding writing time.*

8. *Withholding oil to light one's lamp.*

9. *Being chalked in, not allowed out of one's cell for a prolonged period of time.*

10. *A diet of only bread and water or no food for twenty-four hours.*

11. *Bad time for not fulfilling quotas of production in the factories or other labor; for talking while at work; for having a bad attitude.*

Smoking was forbidden, as was chewing tobacco. Other than the Holy Bible, reading material (magazines, newspapers and books) was not allowed. Inmates could write only one letter per week. School attendance on the nights when it was in session was mandatory. Failure to attend school resulted in punishments chosen from the list above, depending on the resistance displayed. Each inmate was assigned to work for concession contractors, with no say as to the type of work. Quotas in each factory or shop were mandatory, such as making six pairs of shoes or rolling one hundred cigars. An unfulfilled quota for a given day occasioned punishment plus bad time.

LIFE UNDER THE CODE OF SILENCE—AND MORE! THE NIGHT KEEPER'S ROUNDS

Jacktown, despite the Code of Silence, was anything but quiet. Reading John Purves's account of his rounds, one can hear, feel, taste, touch, smell

and see what he was experiencing. The cramped cells inspired some strange behavior from the long-confined convicts. With inmates not allowed to talk under the Code of Silence, the captain of the night keepers writes of those who found alternate ways to use their vocal chords and other sounds to, as Purves stated, "release their pent-up emotions."

One inmate incessantly crowed like a rooster. Sometimes, when told to keep quiet, he would do so. At other times, the rooster in him simply could not stop. As a result, he was either strung up, had cold water thrown on him or was chalked in.

There were screamers, weepers and howlers—the latter claimed to be possessed by the devil. One man whistled painfully shrill sounds. When asked to stop the noise, disturbing as chalk scratching on a blackboard, he would argue that there was no code against whistling, that the rule specifically said "No talking." Realizing that, sometimes, a reward was more effective than punishment to curb abhorrent or annoying behavior, guards might offer an inmate a muffin or an extra cup of chicory coffee if he promised to stop. Many times, this worked. At other times, it proved a short-term solution. In such cases, the reward was not repeated with the miscreant.

Purves understood the effect of boredom on the inmates, particularly as it related to the banning of all reading material except the Bible. Recognizing that humans possessed minds yearning for stimulation, he wrote: "It is my considered opinion that the rule prohibiting talking among the prisoners results in their mind breaking. Judicious selections of newspapers might serve to release this tension under which these convicts labor."

One incident had the prison keepers and guards on tenterhooks. Somehow, a publication instructing sign language had been smuggled in. Before the guards or any prison employee found the well-hidden item, hundreds of inmates had used the tedious hours in their cramped, bookless and hobby-forbidden cells to learn American Sign Language. When John Purves did his nightly rounds, he initially mistook the gestures for the scratching of mosquito bites or bedbug welts, common maladies in the prison. But he noticed, after not too long, that this was not ordinary scratching or swatting. These were organized gestures being performed while one after another inmate stood at the bars of their cells. They stuck their hands out and gestured, then paused, looked at the others as faces strained through the space between the bars, then gestured again as though answering. He quickly surmised that they were speaking in sign language and ordered a search. The magazine that served as perhaps the most effective teacher in the prison was discovered. It hadn't taken long

for even those inmates most resistant to the enforced thrice-weekly classes in reading, writing and arithmetic to learn the language of signing. The Code of Silence was now applied to silent communication. Anyone caught engaging in signing was strung up as though he'd spoken out loud.

Life on the Inside

Beans were a staple of the prison diet. Purves, the night keeper, writes of farters, fantasizers and a sword swallower. Regarding the farters, he claims that, on nights when beans were served at supper, there was a symphony of "bodily wind instruments that filled the air with vile breath." As for fantasizers, Purves speaks of the many written requests he received, including some strange ones. Discussed below is perhaps the strangest request.

Violating the Code of Silence, inmate No. 2296 insisted on humming as he waved his hands in the air in all sorts of patterns. He was told to be silent, but his semiliterate handwritten scrawl explained the situation. No. 2296 claimed to be building "air castles" and said that humming musical airs helped this work. Recognizing that the man sooner belonged in an asylum than behind prison bars, the firm but compassionate John H. Purves granted him a tinker's permit, which allowed the inmate to build his castles. Purves hoped that he would find "some sort of release mentally from the duress of his confinement."

As for the sword swallower, he pleaded for sharp knives, something oily and matches to light fires on the sharp instruments of his trade. He claimed that he had to keep practicing for his eventual release so that he could make a living.

Yet another inmate, a Mr. Dodd (No. 2800), pleaded for tools such as hammers and screwdrivers, claiming he would use them only for good purposes. He claimed to know how to make a "cotton gin that will turn out real gin!" In another case, an inmate was found lying on his cold cell floor, his skin permeated with a blue hue. The man was believed to be dead. The on-duty physician called to the scene felt a slight pulse, but he detected the powerful odor of "spud juice": rotgut liquor made with apples or other fruit taken from the mess hall or farms and fermented with rubbing alcohol. When this inmate sobered up a few days later, he had no choice but to show the authorities how and where he had come by so much alcoholic beverage. On the farm, behind the efficiently and frequently stacked bales of hay, the inmates had seen fit to build a still. To hasten production and make

Prison farms enabled the institution to be self-sufficient and sell produce nationwide. *Author's collection. Photographer, Jon Tulloch; muralists, Hector Trujillo and Jean Weir; historian, Judy Gail Krasnow.*

the strongest possible brew, one of them would, from time to time, feign a malady, be admitted to the infirmary and steal the rubbing alcohol.

The horses and mules used for work on the farms and in the coal mines received prompt and excellent veterinary care, often faster and better than injured or sick inmates received. One clever prisoner reported that a mule was ill. The remedy was to give the animal turpentine to drink. The prisoner gave the critter a few drops and drank the rest himself, ending up, of course, in the infirmary (but not before enjoying a few moments of an incredible, drunken high). Apparently, this addict drank anything and everything, no matter the consequences. Another man did not like his factory job and preferred being in the infirmary. He stole and ate several cigars. Unfortunately for him, his secret was discovered in the objects that projected from both ends of his body.

As captain of the night keepers, John Purves witnessed the sloth of many fellow keepers, who drank on the job or fell asleep while on duty. Some, he knew, simply couldn't adjust to a nocturnal life, and he suggested they request a change of shift or learn how to become night owls. He knew which guards were trusted by the inmates and which had not combined firmness with compassion and were, therefore, mocked or in danger. Any prison employee could be the brunt of the unexpected fury or temporary madness of an irate inmate. Anyone could be attacked. One keeper was calmly called to the cell of an inmate claiming illness. When the keeper arrived, the furious inmate tossed the contents of his honey bucket all over the man. The keeper was

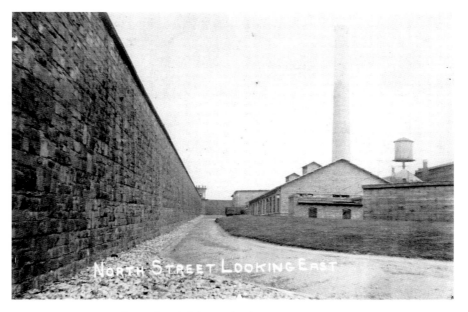

Inside the prison wall. The only relief from cells, factories and the wall was the daily one-hour glimpse of the sky. *Courtesy of Jackson District Library.*

immediately sent home not only befouled but also in terror of contracting dysentery or any of the other diseases rampant in the prison, including tuberculosis, measles, smallpox and syphilis.

Other disturbances to the silence included stray cats in heat, crying loudly and screeching and hissing on the prison grounds, waking the inmates. New prisoners, delivered at night, were often brought to the prison gate by the town sheriff, who was seldom sober. The night keepers wondered how many newcomers they'd lost—before the drunken sheriff could reach the prison gate, he'd often fall down and be unable to get up.

Often, a keeper would do his rounds only to find a man hanging from the top bar of his cell by a belt, a rope or a torn piece of a blanket. One howling inmate, standing and shaking the bars of his cell, had a nasty, raw red mark on his neck. When the guard asked what had happened, the man wept and cursed profusely. Furious, he cried that he had tried to hang himself with his belt, but that the buckle had broken. "I want to die. There is no escape. There is no life in this hell-hole." He was not alone in his desperation. Attempted suicides were not uncommon. In solitary confinement, suicide was often achieved without hanging. The distraught inmate would bang his head against the hard brick-and-concrete wall until he died.

Attempts were made to saw through the prison bars or the wall, floor or ceiling. In most cases, the sound of sawing led to the culprit's discovery before a successful escape. For several nights at one point, a sawing sound echoed through the cavernous halls. It woke the inmates, who challenged the guards to find out who was causing it and stop him so they could sleep. It turned out to be Miller, No. 1626. He had been ignored because he was always on his cot, fast asleep, when the guards passed his cell as they searched for which inmate possessed an implement that could saw through brick, stone and concrete. On this night, after several fruitless searches, Purves realized it was, indeed, Miller who was responsible for the sound. He was grinding his teeth! It was so loud that Purves wondered how he had any teeth left.

Two inmates, one a former soldier in the Confederate army and the other a soldier from the Union army, continued the Civil War some twenty years after it had ended, screaming, fighting and standing their ground, each one insisting on the rightness of his belief. They were, of course, separated. However, in the prison yard or in the mess hall, the Confederacy fought against the Union, and vice versa. Then, there were the two lifers in their seventies, Moses Talbot (No. 36) and William McDonald (No. 52), allowed to wear long, white robes. They resembled prophets of old roaming the

Two hall masters were in charge of conduct while inmates were marched from place to place. They did the laundry, dispensed uniforms and performed other duties. *Courtesy of Jackson corrections officer Douglas Rennaker.*

The night keepers pose, with John H. Purves (with mustache) in the center. Also shown is Walter Bearse. *Courtesy of the family of Walter Bearse.*

Arabian Desert. They each had a long white beard. One night, the men, harmless and too feeble to cause danger, surprised John Purves, who found them wandering the cellblock yelling at each other. The yelling escalated into a brawl, and Purves ran to the scene. The men were on the floor, tearing and scratching at each other. Talbot flailed his thick cane, further escalating the mêlée. Despite their age and weakness, Purves was unable to pull them apart. Their fury knew no bounds, and their adrenalin gave them added strength. Finally, Purves told them that if they didn't let go of each other, their punishment would be the shaving off of their beards. In an instant, the two disengaged and shook hands in peace. That was the last of their fights.

Attempted escapes were frequent. The buildings were not properly maintained, so doors could often be easily pried open, or pieces of soap could be secretly thrust into locks, making them appear to be locked but, in reality, not latched properly. Areas of the ceiling in the older West Wing had rotting boards and loose stones and bricks; some convicts worked their way out of the building through these weakened areas and climbed down the bars on the windows. Most were caught, spotted by an alert guard.

One inmate, though, proved to be particularly clever at manipulating the decaying infrastructure.

One night shortly after midnight, some of the smaller pumps in the coal mine began malfunctioning, and convict Muhlberg (No. 2006) was taken to see what he could do. Although new in mine detail, he claimed to understand the mechanics of the pumps. He did his handiwork, replacing a small valve. Then he commented to a guard named Binns that the rug at the door was so dusty that it needed cleaning and, while there, he would be happy to do the job. He pounded away at the rug with a rug beater, the sound of which indicated that he was performing the task. Soon thereafter, the sound stopped, but Muhlberg did not reappear, nor did the rug. For several days he went missing. Guards, as they did when escapes occurred, combed area farms, including barns and fields, and knocked on farmhouse doors. Muhlberg was found days later, with the rug, sheltered in the home of a farmer and his wife, who had fallen for his story that he was a traveling preacher and had been robbed. To enhance his subterfuge, he had removed all his clothes down to his underwear in order to appeal to the couple's generosity. On being captured and told to "throw up your hands and don't move," he replied, "What's a man to do in a situation like that?"

Another convict escaped by managing to walk out of the gate as the guard on duty slept (not an uncommon occurrence). A gang of horsemen he knew met him shortly after midnight outside a saloon. The timing of his escape and of the horsemen's appearance eventually led to his capture, as well as that of his accomplices.

Night keeper John H. Purves is shown in an image from his *The Night Keeper's Reports 1882*. The book is available at the Old Prison Gift Shop, Armory Arts Village. *Courtesy of Jackson Historic Prison Tours.*

Many transients came to the prison gate looking for a bed on which to sleep. Upon arriving, they'd run in terror as armed guards informed them that this was a penitentiary. And what a penitentiary it was, with its farts; sounds of inmates imitating a donkey braying or a rooster crowing; cries such as, "You make us work all day and lock us up at night"; a convict weeping for a pet canary named Salome's Nose; sleeping guards; drunk guards; prisoners fighting with guards; prisoners fighting each other; bread balls thrown by a prisoner at the bald pate of another in

the mess hall; the creation of imaginary air castles; turpentine and spud juice highs; wails and howls; suicides; escapes; medieval punishments; cockroaches, bedbugs and deadly diseases; and cheap labor producing goods at the height of the Industrial Revolution. Yes, Michigan's first state prison prevailed, revealing many a story to be told. John H. Purves was a masterful storyteller.

The next story is just one of many that life in Jacktown produced and that Purves penned in his reports.

The Cockroach and the Cigar

On one particular night, John H. Purves, captain of the night keepers, began his rounds. Walking into the West Wing, he noticed that the usual gut-wrenching smell of filled honey buckets was competing with another, far more pleasant scent—that of cigar smoke. It was an odor that the keeper liked and that brought back memories of tent life on the battlefields of the War Between the States.

But in the prison, smoking was prohibited. Someone was going to suffer punishment for such an infraction. Purves lit his oil lamp to approach the narrow gallery walkway and find the culprit. Before he took his first step, he stood still with amazement at the scene revealed by his lamp.

MSP was a mighty fortress whose walls, floors and ceilings included woven steel behind and under them. After the escape of the Jackson Robber Gang from the fort, officials made sure that this brick-and-mortar prison would preclude any chance for an inmate to dig his way out. A side effect of this construction was that, except for areas near the mess hall and its garbage, rats were not a problem. Yet there are other creatures that have the ability to slide their way into most any location: cockroaches! The prison swarmed with them, huge ones akin to the Madagascar hissing cockroaches, which were from three to four inches long. What Purves witnessed now was the use of one of these critters as "free labor."

The inmate in the first cell lifted a cockroach with a smuggled, lit cigar tied to its back. He took a long, pleasant puff, slowly exhaled and set the insect down outside the bars of his cell. The roach began to run, but it could only get as far as the next cell, for the length of the string had been calculated for just that purpose. The next inmate reached out, pulled on the string, drew the bug into his cell and took his prolonged puff. When done, he held the string until inmate number three pulled the frantic cockroach

Cockroach at Work

Human ingenuity was used to gain a small amount of pleasure, as in the story of the cockroach and the cigar in *The Night Keeper's Reports. Courtesy of Jackson Historic Prison Tours.*

into his cell. This use of cockroach labor continued down the entire length of the cellblock.

The night keeper later wrote in his journal that, after watching this spectacle, he simply flicked out his oil lamp and walked away, as he was "astounded and confounded at the ingenuity of the human imagination to figure out ways to find a bit of pleasure even in the direst of circumstances." Purves did not report the infraction, and no one incurred punishment.

THE CODE IS REPEALED

The Code of Silence ended as law as a result of the women's suffrage movement. Alice Paul and others, including the wives of some senators and representatives whose husbands left them and took their children away because of their participation in the movement, suffered arrest numerous times. For simply speaking out to request lawyers while imprisoned, the women were strung up by their wrists, their feet off the ground, and left hanging this way for hours, sometimes days. They suffered many

unendurable punishments, which visiting relatives, including some politician husbands, reported to various newspapers. This horrendous treatment and resulting maiming and illness cast President Woodrow Wilson and America in a barbaric light. As a result, the Code of Silence ended, finally taken off the books. Shortly thereafter, the Nineteenth Amendment passed, granting women the right to vote. Lucy Burns, wife of Senator Harry Burns, was one of those incarcerated. After much persuasion by fellow congressmen, Senator Burns reluctantly cast his pivotal vote for the Nineteenth Amendment.

INFAMOUS JACKTOWN RAPSCALLIONS

The fame of notorious criminals is fickle and short-lived, with some exceptions. For example, Jack the Ripper, whose name is still known today, nearly two centuries after his crimes, shocked the world, introduced the idea of serial killers and, ultimately, brought to light the mental state called psychopathology. Other names may be remembered, such as Jeffrey Dahmer, Ted Bundy and even John Norman Collins, who, between 1967 and 1969, cruised on his motorcycle in the Ypsilanti and Ann Arbor university area, convincing young coeds to climb on and go for a ride. They never returned. Jacktown harbored some colorful miscreants who were infamous enough to become legendary.

Silver Jack Driscoll, a logger, weighed about two hundred pounds and stood six feet, four inches tall in an era when the average height for a full-grown man was five feet, ten inches. Silver Jack brought his own personal kind of circus to towns on both the upper and lower peninsulas. Folks expected exciting entertainment with the arrival of this hulk of a famous logger, even if that entertainment was a brutal, disruptive brawl. Whatever the mischief, it would be as dazzling as any performances under the big tent. Silver Jack was a masterful axman and log driver—and drinker. Money would flow into any bar he entered; rounds of drinks were often on him after he'd thrown someone who dared insult or challenge him across the room. Jack would then pummel the poor soul while breaking tables, chairs and lamps. His two terms in Jacktown were attributed, needless to say, to alcohol.

Driscoll's first arrest was on February 26, 1873. Having drunk away all his hard-earned logging money, a friend offered Driscoll, at his expense, to share

a room in a local hotel. Silver Jack accepted the offer. The next morning, the friend woke up to find himself robbed of money and his gold watch. A search ensued. Silver Jack, recognizable and too hungover to get far enough away to avoid being apprehended, served five years. It was during this time in prison that he encountered another giant of a man, Edgar Hannibal, who insisted on being called "The Bear." Like Silver Jack, Hannibal stood over six feet tall; unlike Driscoll, he weighed over three hundred pounds. Covered with thick hair, Hannibal's hands resembled the paws of the animal he chose as his namesake. He entered Jacktown on December 29, 1874. These two men had frequent encounters, to the dismay of guards and inmates alike.

Silver Jack walked out of prison on May 5, 1877. He actually stayed clear of trouble with the law for three years. Then July 1880 rolled around. In a Saginaw bar, Silver Jack shook up the place with his foul language, insults, huge fists and big biceps. Downing whiskey and rotgut gin by the gulp, he finally passed out, slumped on the bar in an alcoholic stupor. A man who bore the brunt of Driscoll's insults decided who would ultimately win. He informed the town police that he had been robbed at gunpoint by Silver Jack.

Some say the $2.50 in Silver Jack's pocket, accompanied by a revolver, was placed there as a practical joke, planted by someone wishing to get even. The folks who believed in Silver Jack's innocence in the matter pleaded with the police not to send Driscoll to the clinker; but it was jail for Jack. He woke the next day after a heavy-duty blackout and with no memory of the previous night's occurrences. Later, at his trial, the judge asked Driscoll if he had anything to say. He pleaded innocence and claimed an unfair trial, arguing that the jury members were drinking water, dozing off and not listening. He begged for a new trial. But the gavel came down loud as the judge sentenced Silver Jack to fifteen years of hard labor in Jacktown.

A newspaper predicted that Silver Jack would "get his due" in prison, and this turned out to be accurate. In a brawl with three other inmates, Silver Jack was stabbed with a knife several times. He managed to recover, and the incident prompted him to attempt some daring escapes. At work in the shoe factory, he persuaded inmates to nail him shut in a shoe crate, allowing him to be shipped out as a delivery of shoes. One observant guard noticed unusual activity in the packing area of the factory. When he went to lift the crate, it weighed far too much to contain only shoes. He opened it and found the cause of the heaviness: Silver Jack! In another escape attempt, Silver Jack concealed himself under hay in a wagon parked near the train tracks. He knew the schedule of the many trains that passed and could hear the whistles as they approached. He timed his leap out from under the hay onto

the top of a passing freight train. An alert guard turned around when he heard an unusual sound coming from the wagon. He shot Silver Jack in the leg, preventing him from running. The train came to an abrupt halt. Driscoll returned to prison and solitary confinement—its darkness, discomfort, diet of bread and water and the swings of a bat on his back.

Silver Jack became the subject of a widely sung ballad in the days of tall-tale loggers. The song was based on a particular incident. In a saloon, a man dared to blaspheme Jesus. Silver Jack's Catholic upbringing would not tolerate sacrilege against his mother's religion. He engaged the man in a battle of thunderous slugs. Silver Jack never used weapons. He didn't have to. His brute strength, claw-like nails and teeth (with which he once ripped a man's cheek off) were better than any weapon he might wield. The slugs and bites in this fight, prompted by his defense of Jesus, forced his opponent to plead for mercy, promising to never again speak against the Lord. Word of this brutal fight spread far and wide and resulted in the following anonymously written ballad, called variously "Silver Jack the Evangelist," "Religion in Camp" and "The Lumberjack's Revival":

> *I was on the drive in 'eighty*
> *Working under Silver Jack,*
> *Which the same is now in Jackson*
> *And ain't soon expected back.*
>
> *There was a chump among us*
> *By the name of Robert Waite,*
> *Kind of slick and cute and tongue,*
> *Guess he was a graduate.*
>
> *He could gab on any subject*
> *From the Bible down to Hoyle,*
> *And his words flowed out so easy,*
> *Just as smooth and slick as oil.*
>
> *He was what they called a skeptic,*
> *An' he loved to sit and weave*
> *Highfalutin' stories*
> *Telling what he didn't believe.*
> *One day while we were waitin'*
> *For the flood to clear the ground,*

We all sat smoking cheap tobacco
And hearing Bob expound.

"Hell," he said, "is all a humbug,"
And he showed as clear as day
That the Bible was a fable,
And we 'lowed it looked that way.

Miracles and suchlike
Was too thin for him to stand;
And for Him they called the Savior,
Why he's just a common man.

"You're a liar!" someone shouted.
"And you got to take it back!"
Then everybody started:
'Twas the voice of Silver Jack.

He chucked his fists together,
And he shucked his coat and cried,
"'Twas by that there religion
That my mother lived and died.

"And although I ain't always
Used the Lord exactly right,
When I hear a chump abuse him,
He must eat his words or fight."

Now this Bob weren't no coward,
And he answered bold and free,
"Stack your duds and cut your capers,
For there ain't no flies on me."

They fought for forty minutes,
And the lads would hoot and cheer
When Jack spit out a tooth or two
Or Bobby lost an ear.

But Jack kept on reasonin' with him
Till the cuss begin to yell,
And Bob 'lowed he'd been mistaken
In his views concerning Hell.

Then Jack he got Bob under
And he slugged him on't or twic't,
And Bob straightway acknowledged
The divinity of Christ.

So the fierce discussion ended,
And they got up from the ground,
An' someone fetched a bottle out
And kindly passed it around.

And they drank to Jack's religion
In a quiet sort of way,
And the spread of infidelity
Was checked in camp that day.

HANNIBAL "THE BEAR"

Today, we know about the autism spectrum, along which lies a condition called Asperger's Syndrome. Among its characteristics are a beer belly even in the absence of beer; a growly voice in male; sensitive skin that "hears" irritating noises when touched; an easily aroused temper; inappropriate or antisocial behavior; misinterpretation of tones of voice and teasing that to someone else would be recognizable as not threatening; and the need to be alone and in silence when surrounding noises become too loud to tolerate. Edgar Hannibal had all of these characteristics (though, it must be said, it cannot be determined if he fell on the autism spectrum).

The crime for which Hannibal entered prison on December 2, 1874, at the age of thirty-four, was larceny. Inmate No. 506 served for three years before his release on July 3, 1877. Night keeper John Purves knew trouble was at hand when the new convict entered and, in his growly voice, made it clear that no one was to give him a nickname. He announced gruffly that he was to be called "The Bear." Hannibal couldn't read or write, and at the required classes, he was unable to learn to write or recite the alphabet.

His temper flared when anyone commented on his illiteracy or laid a hand on him, even in a friendly gesture. His easily aroused temper responded with brute force. He was known to break more jaws and crack more skulls than any other prisoner before or after. He returned for a second round in Jacktown on May 10, 1884, this time for larceny and the added count of assault. Purves tallied up his time in solitary at his release five years later. He claimed that the time "The Bear" spent in "the hole" amounted to approximately four of his eight years of incarceration.

The story about how he earned a second stint in Jacktown is interesting. On the logging campground in Kent County, another logger, wielding an axe, ran toward Hannibal, threatening to kill him. Hannibal, far stronger than the man, turned and ran toward him. As the other logger held a tight grip on the axe handle, Hannibal yanked it from him. The force with which Hannibal pulled it out of the fellow's clutch resulted in the man falling on the ground. Looking up at the huge, hairy brute now standing with axe in hand, the other logger's yelps of terror drew the attention of the camp guards, who ran to the scene. When a peace officer intervened to arrest Hannibal and demand that he return the axe, in true character, Hannibal struck the officer's shoulder with his bearlike fist, nearly knocking him down. Hannibal refused to let go of the axe, claiming he wanted it, that it was a good axe and that he was a good logger who deserved a good tool. He did not threaten the officer with the axe—his fist was all that was needed. No trial was held or questions asked. Theft of the axe and assault landed Hannibal in Jacktown for another four years.

Purves described "The Bear" as a man who, by all appearances, had been abandoned as an infant to be raised by wolves. As time went on, Purves sensed a gentle and kind heart underneath the violent outbursts. Hannibal was a great worker when left alone. Ultimately, Purves got Hannibal placed in a corner of his own as a metalworker welding wagon parts in the Jackson Wagon Factory. Until then, however, some major disturbances resulted from his incarceration.

Hannibal's three-hundred-pound frame barely fit in the three-and-a-half-foot by six-foot cell. Sleep did not come easily, as his girth hung over the side of the narrow cot and his great height forced him to sleep in a fetal position, knees to his chin. His protruding belly made this quite difficult. He snored with bearlike rumbling, and the other inmates would call out constantly to the guards to "shut The Bear up so we can sleep!" Hannibal attempted to exercise in his small quarters, grunting, panting, jumping and banging into the bars, which rattled and echoed each time he stretched or bent down in his tight living quarters. When told to stop, he claimed that he had to

exercise and keep his muscles strong for the time when he would be released and return to logging.

Purves had his hands full with the two unruly, physically strong loggers. Silver Jack and Hannibal would repeatedly create havoc. Silver Jack would yell abusive words at the guards and make demands, such as, "You key-jangling old mossbacks had better get me some oil for my lamp, and get it damn quick or I'll tear this place down and toss it in the middle of the street." Hannibal ended up cuffed to the bars in cell No. 24 in the East Wing after, for seemingly no reason, he pummeled inmate No. 2463, a fellow named Christianelly, leaving his head injured from the severe blows.

Purves describes Hannibal's huge appetite, particularly when released from solitary. Purves found that on a one-to-one basis, and with food as an enticement, he could have a calm and reasonable conversation with Hannibal. One night, as the night keeper released Hannibal after a ten-day stay in solitary, he took him to the kitchen for some genuine food. Hannibal piled his plate with three steaks and a mountain of mashed potatoes. He went back for three more plates of potatoes. When returned to his cell, he quietly climbed onto his too-small cot and covered himself from toes to head with his blanket. Soon, those bearlike snores began.

However, there were plenty of other incidents displaying Hannibal's ferocious behavior. He picked up tables and threw them at a Canadian convict who relentlessly teased him. He stole a sausage from the plate of a man in the mess hall. When the poor fellow pleaded with Hannibal to give it back so he could eat it as a bedtime treat in his cell, Hannibal walloped him on the head, knocking him unconscious. The doctor was called, and Hannibal was returned to solitary.

Silver Jack Driscoll goaded Hannibal, hoping to provoke a fight and see Hannibal sent to solitary. One night, a mêlée ensued that left Silver Jack and another convict, Rudolph Ranson (No. 3423), with fractured skulls. Hannibal claimed he saw Silver Jack with a knife in his hand, sneaking up on Ranson. In order to stop Silver Jack from stabbing Ranson, Hannibal lunged at Silver Jack. Ranson, unaware that he was about to be attacked by Silver Jack, jumped in, thinking Hannibal was about to attack Silver Jack. Ranson was unaware that he was about to be attacked by the man he now sought to protect. Hannibal ended up injuring both Ranson and Silver Jack. No knife was found, but Silver Jack and Ranson ended up in the prison infirmary. Hannibal ended up in solitary, awaiting the warden's decision on who should or should not be punished and how.

Someone posted handwritten letters in misspelled scrawl on Hannibal's cell in attempts to get him in trouble or to make the guards think Hannibal was up to some secret plot to destroy something or someone or that he was planning an escape. Purves never fell for these forged notes—he knew Hannibal could neither read nor write.

Amid all this ferocity, Hannibal had moments when he was genuinely helpful. A foreman in the wagon factory tried to round up a crew to move a 450-pound anvil from one end of the huge room to the other. Hannibal simply walked over to the anvil, lifted it and carried it to the requested spot.

The following vignette brings to mind the character of John Coffey in Stephen King's *The Green Mile*. In the novel and subsequent film, Coffey, wrongly accused of murdering two little girls, awaits execution. A huge, powerful man, Coffey has mystical powers to see through and beyond things. He wears a bag of healing herbs in a small sack around his neck. At Jacktown, a guard named Moorman found what he described as a "foul-smelling cloth bag dangling from Hannibal's cell bars on a long string." The guard removed it and threw it in the garbage. Hannibal was beside himself, claiming it was his good-luck health bag. He informed Purves that he might come down with some dreadful disease if he didn't have the bag back. He was inconsolable. Upon further questioning, he told the night keeper that the bag contained an herb called asafetida. Purves felt this was so important to Hannibal that he acquired some of the "vile" herb and gave it to the anxious convict.

An occurrence involving Hannibal later became a running cartoon in the *Spectator*, one of the oldest prison publications in the country. Hannibal himself became a popular cartoon character in this publication for years, even after MSP closed.

As John Purves made his rounds one December evening, not too long before Christmas, he heard a peculiar sound coming from Hannibal's cell. The growling voice repeated over and over again, "Knit one purl two, don't drop. Knit one purl two, don't drop." As the night keeper approached the cell, he watched in amazement. Hannibal was so absorbed in what he was doing that he wasn't even aware of the presence of Purves. In all his years in Jacktown, no one had visited Hannibal or written to him. No one had even inquired about him. How, and from whom, did he get what Purves now saw in his hands: two bone knitting needles and beautiful, colorful wool? Hannibal was knitting in prison in an era when a man caught knitting would be the subject of question and ridicule. Indeed, Hannibal soon became just that.

This is a cartoon of the infamous troublemaking logger Edgar "the Bear" Hannibal from John H. Purves's *The Night Keeper's Reports. Courtesy of Jackson Historic Prison Tours.*

The other prisoners found every opportunity to torment Hannibal, making feminine gestures and miming knitting. The worst incident began when Silver Jack attempted to grab the ball of yarn. The commotion caused the yarn to fall to the floor. It rolled, unraveling over the gallery railings. Hannibal, outraged, reached through his cell bars and grabbed Silver

Jack by the throat. Four guards came running in response to the obviously dangerous commotion. Silver Jack was turning blue, and his eyes began to bulge from their sockets. It took all four guards to pull the two men apart. The expression of hurt and sorrow on Hannibal's face made it clear that he was not the provocateur.

The wool was gathered. The knitting went on. Hannibal was so intensely involved in his knitting that, in spite of his enormous appetite and eagerness to get to the chow line quickly, he missed dinner.

The answer to the mystery of the knitting came on Christmas Eve 1882. Purves was on duty. He likened prison on Christmas Eve to walking under an ocean: a depression so intense that it felt like the pressure of tons of water. He approached Hannibal's cell. "Mr. Purves," he heard the growling voice. "Mr. Purves, I know I am not supposed to talk until you talk to me first, but Merry Christmas."

The big brute walked to the cell bars and slipped through them a package wrapped in scraps of paper glued together, paper he'd collected at his job in the wagon factory. "Take it," he said, the rasp in his voice sounding a bit choked up. "Merry Christmas."

"Well, thank you, Hannibal. I will put it under the tree when I go home."

"No! Open it now, here, while you are here with me. It's for you. I want you to see it while you are with me."

Purves pulled off the glued wrapping paper. The gift was a beautiful knitted scarf, not one knit or purl dropped. Overcome with emotion, tears welled up in Purves's eyes and began to flow down his face. "Oh, no," he thought. A guard is never to be seen showing emotion. "If word gets out, I'm a cooked goose!"

Hannibal meantime had hung his head and was looking toward the floor of his cell. It was then that John H. Purves realized that Hannibal was looking down, not to avoid seeing the tears of the night keeper, but to hide the fact that the little drops of water falling on the cell floor were Hannibal's tears.

In 1887, when he was released, Hannibal went to Petoskey and found a job as a logger. People in the town and surrounding area spoke of a huge, hairy man of great strength, a hearty logger who had done time in the Jackson prison. Interestingly enough, when the prison sent its emissary to check up on this logger, whom they said was Edgar Hannibal, or Hannibal the Bear, or just The Bear, there was no one by that name in the logging books. The officer asked to check the books. There was no listing. However, he did find a listing for a Silver Jack Driscoll. "Strange," he said. "Silver Jack is still doing time. Let me see this Silver Jack." The officer waited while

another officer found Silver Jack and brought him to the office. In walked a three-hundred-plus-pound, hairy, six-foot-plus man with a big belly and a voice with a growl like a bear.

"Well, howdy," said the officer. "I see you've changed your name, Hannibal. What a story I have to tell John Purves and the others. You've taken on the name of your archenemy, bad 'ole' Silver Jack Driscoll. Only resemblance to that name as I see it is that your hair has turned silver since you did time."

And so it was that, under the name of his nemesis, Hannibal the Bear stayed out of trouble and didn't return to Jacktown or any other prison, as far as anyone knows.

OTHER SCOUNDRELS
AND A BUNGLED ESCAPE

The list of characters residing in Jacktown goes on and on. It would require a book unto itself to discuss all of them. What follows are the stories of just a few more.

SILAS DOTY

Silas Doty, born on August 30, 1800, in St. Albans, Vermont, got his thrills beginning in childhood from thievery and any lawbreaking activity that filled him with the pleasure of excitement and deceit. At age nine, he already had a thriving business. He stole animals from the traps of fur traders and sold their furs for good money. Later, he learned the trade of a blacksmith and became an expert key forger, allowing him to break into all sorts of establishments and rob them of their goods. Before the fearsome yet romanticized era of Jesse James, Silas Doty robbed, burglarized, stole horses and rode on these stolen animals as a highwayman. He claimed (as Jesse James did in later years) to rob from the rich and give to the poor. Doty also became a notorious criminal gang leader.

His thievery took him to England, the Midwest, New York, Mexico and, ultimately, to Jacktown in 1851. His incarceration followed several years of conniving to postpone trials and lessen sentences, all the while allowing him the freedom to commit further crimes. Finally, he received a seventeen-year sentence at MSP. After serving fifteen years, he was released for good

behavior. As soon as he got out, he stole a horse, got caught and received four more years behind bars. Once again, upon his release, he could not give up his addiction to the thrill of a life of thievery. In his seventies, he returned to the Jackson prison. He died on March 12, 1876.

A posthumous, highly boastful autobiography was released by J.G.W. Colburn, published four years after Doty's death, titled *The Life of Silas Doty: The Most Noted Thief and Daring Burglar of His Time, 1800–1876.*

IRVING LATIMER

After the demise of Irving's father, the family-owned pharmacy was going under as the result of Irving's unrestrained tastes, which now included wooing women with free milkshakes if they purchased an item in his store. At the age of twenty-three, he was living with his widowed mother and needed money. She loaned him $3,000, quite a sum in the 1800s, and had him sign an IOU. On January 4, 1889, Latimer put an end to the IOU. He returned to the house after dark, in the late hours of the night, after going to Detroit. He had told his mother that he'd be away for a few days. His dog recognized him and didn't bark while Latimer brutally ended his mother's life. Then, he boarded a 6:20 a.m. train back to Detroit.

Irving tripped up in several ways, including not changing his bloodstained clothes, figuring he could pass the blood off as the result of a nosebleed. At the hotel where he normally stayed, a maid saw him slip out a side door. His bed had not been slept in and was discovered the next day still made. He claimed that he had not stayed at the ritzy hotel of his choice because he was to meet a married woman for a tryst in Chelsea, but he was identified as a guest at a hotel of lesser status in Detroit when he was supposedly in Chelsea.

All the evidence at his trial led to Latimer's guilt and subsequent sentence of life in Michigan's first state prison. The evidence assured the judge and jurors of the following facts:

1. *That he had indeed gone to Detroit.*
2. *That there was no trace of "Trixie," the supposed married woman.*
3. *That the .32-caliber gun that shot his mother was found in his drawer in the pharmacy.*
4. *That he had boarded the train back to Detroit with his bloody clothes not long after the time of his mother's death as determined by the coroner.*

At MSP, his good behavior won him the position as a trustee, allowing him to work in the prison pharmacy. Mixing poisons into lemonade, he managed to leave one guard unconscious and escaped through the East Gate, where his poison lemonade killed that gate's guard, George Haight.

Latimer was not good at covering up his crimes; as a matter of fact, he was downright careless. Bedraggled and still wearing his prison pants with the number 4578 on the waistband, those who found him got their $1,000 reward. Latimer insisted he was not responsible for Haight's death, claiming that the other prison employees found the man too late to get him proper medical care, unlike the case with the unconscious guard, who was found in time to be saved.

A couple of years ago, George Haight received a posthumous honor at the memorial in Washington, D.C., dedicated to officers killed while in service at prisons. Haight's descendants attended and later took the Jackson Historic Prison Tour. Visitors included Haight's great-great-granddaughter, great-great-great-granddaughter and great-great-great-great-granddaughter and grandson. They wanted to see where their ancestor had worked—and died. The young children touched every inch of the interior walls and the exterior walls, saying, "Maybe his hands touched here, too." It was quite an

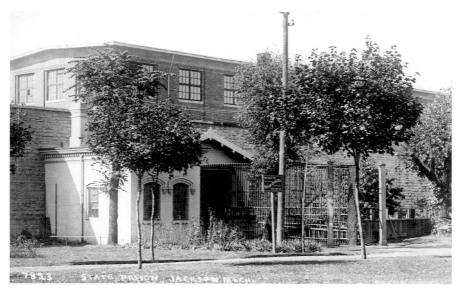

The East Gate, built when the east cellblocks were constructed, became the entrance and exit for new inmates and all deliveries. *Courtesy of Jackson District Library.*

experience to meet the living relatives of a man whose story is part of the Jackson prison's history.

As for Irving Latimer, his life in Jacktown resumed. His talents as a poisoning pharmacist were outdone by a good talent. He proved an excellent horticulturist. He landscaped the beautiful gardens that ultimately adorned the front of the prison. In 1934, when the old prison closed, he remained living there to tend the gardens and to work the greenhouse, where seeds were grown in its warmth during the winters for planting when the spring finally arrived. Resigned to his fate behind bars, he was often allowed out and could walk into town to purchase necessaries and simply breathe fresh air.

A BUNGLED ESCAPE

In 1919, a well-behaved trustee had the job of accepting deliveries at the East Gate. Unbeknownst to the authorities, the inmate knew that some of the packages contained dynamite. Two other convicts had suckered him into their escape scheme. They would bury the delivered packages of dynamite at various points on the prison grounds. When enough had been acquired and stashed away, the two convicts' wives would be on call. The three men would ignite the dynamite and blow up the North Guard Tower. Their wives would wait in a green Pontiac around the corner. As the prison tower and wall at the north corner exploded and all the guards and other officials would be distracted, the three convicts would escape from a place at the wall where they calculatingly would have blown a hole.

For weeks, their dynamite and necessary equipment secretly came through the prison gate to be buried at points where construction was taking place within the prison walls. The trustee nervously carried out his orders, threatened by the other two men. Ultimately, the fear of consequences got the better of him. He may have robbed, even gotten into a brawl or two; but he was not a murderer. The thought of deaths at his hands, even as an accomplice, did not sit well with him. He finally reported the escape plot to the authorities. He told them where they could dig up the packages of dynamite and the names of the two instigators.

Sure enough, the packages were found. The plot was uncovered. To protect the "snitch," he was sent to Marquette Prison, a maximum-security facility opened in 1889 and to this day called the Siberia of the North. There, no one would know what he'd done at Jackson. The other two perpetrators

were confined in solitary. Their wives ended up in the Detroit House of Detention for Women with long sentences. Eventually, the honest trustee was returned to Jackson, and the two instigators were sent to Marquette. This was not out of gratitude on the part of the authorities. It was due to the fact that, at Marquette, the former trustee's snitching became known, and his life was in danger. At Jacktown, snitched or not, he was ultimately respected for saving lives, including those of many inmates, who could have died in the explosions and potential ensuing fires. He was no longer given duty to accept packages at the East Gate, and no prisoners confided to him their escape plots or any other secrets. Eventually, he gained his freedom.

PROHIBITION AND CORRUPTION

Michigan was the first state to go dry during the era of Prohibition (1920–33). The banning of sales and imbibing of alcoholic beverages resulted in the rise of dangerous, deadly gangs who fought each other for territorial routes to transport and sell bootleg liquor. The opening of speakeasies, often called "blind pigs," led to an underground world of infamous gangsters whose notoriety achieved Hollywood-level, almost romantic heights. Since being caught drinking was a crime, the Jackson prison was bursting at its seams with overcrowding and exhibiting unlivable conditions. It had been condemned in 1914, with talk of building a new facility some three miles farther north along Cooper Street. Such projects take planning and time; in the process, political payoffs and corruption occurred. Such corruption was plentiful among the following: those involved in the planning; companies vying for the construction jobs such an undertaking would require; the state, wishing to maintain its reputation for having the largest walled prison in the world; and politicians and prison officials, who sought control and decision-making powers.

In the meantime, society responded with the growth of lawlessness through an underworld of mobster rule. These mobsters continued their techniques of rule and power within the prison walls during incarceration.

The murderous Purple Gang even threatened big, bold Al Capone not only to give up some of his territory but also to purchase much of his bootleg liquor from them. Capone did so in order to stay alive himself, and the Purple Gang made a sort of peace with Capone so his henchmen would not come after them. Among the Purple Gang's leaders were the Keywell brothers, Harry and Phil. Both were finally caught and imprisoned in Jacktown, but

only after they'd put many a man to a miserable death, as well as a fifteen-year-old who happened to walk through a wooded area on his way home from school. Harry was loading the trunk of a car with bootleg liquor. Afraid that the boy would report this, he brutally murdered the young man. Purple Gang activities didn't stop with incarceration. The Keywells simply ruled and ran the prison with their racketeering tactics. As for Capone, Jackson police repeatedly attempted to foil him when he came through en route to either Detroit or Chicago. But he always foiled them, changing his route plans at the last minute.

While in Jacktown and, later, the State Prison of Southern Michigan (SPSM) a few miles north of the old prison, the Keywell brothers and a few other Purples who had also been caught and incarcerated openly brought in bootleg liquor, drugs and women. They were allowed out on weekends to go to baseball games, blind pigs and brothels. The warden and his deputy even gave them street clothes to wear for these outings. It wasn't a rare sight to see them in the bleachers at a Detroit Tigers game or dining in one of their favorite restaurants.

In 1944, they would be suspects in the execution-style murder of Senator Warren G. Hooper as he drove his green Mercury from Lansing to his home in Albion on January 11, 1945. The car of the deputy warden of SPSM, D.C. Petitt, painted maroon from its original black for the occasion, was the suspected vehicle, used with full knowledge of the deputy warden and Harry Jackson. Jackson, now warden of SPSM, had been warden at Jacktown before moving to the new mansion for wardens at SPSM. He served four times as warden, going in and out of the position according to which political party held office. Corruption in the state government was rampant, and Hooper, at a state hearing, was about to give his own version of the corruption and how he'd been pressured into it with bribes.

There were times when the line between criminals and those in authority was slim—if existent at all. In 1918, Harry Hulbert became warden of MSP and served until 1925, the year Harry Jackson began his first appointment in the position. Hulbert had a good sense of business—that is, business involving political maneuvering and payoffs. But he had a poor sense of running a prison. On the one hand, he made progress by leading the prison into the business of manufacturing cement, license plates and textiles. On the other hand, he appointed William Hopp as the prison's chaplain. Hopp owned a brothel in Detroit, at which his wife presided as madam. Hopp was later named as a principal in the selling of drugs and paroles within the prison. Often, in exchange for parole, the inmate was

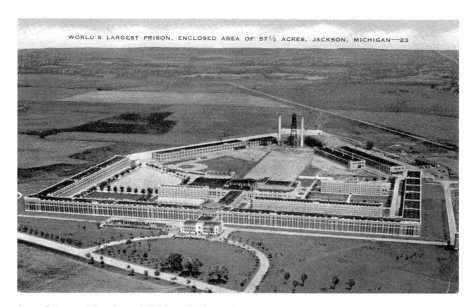

WORLD'S LARGEST PRISON, ENCLOSED AREA OF 57½ ACRES, JACKSON, MICHIGAN—23

State Prison of Southern Michigan is shown in 1934, when it opened. It was the largest walled prison in the world at the time. Built for 5,800 inmates, by the time of the 1981 riots, it held over 12,000 prisoners. *Courtesy of Jackson Historic Prison Tours.*

required to offer his wife for sexual encounters with officers, with Hopp and at Hopp's Detroit brothel.

In spite of Hulbert's shady associations and dealings, for which he was eventually fired as warden, he was later placed in charge of building what would become the State Prison of Southern Michigan. In Illinois, a penitentiary was being built that was to occupy 57 acres. Hulbert followed the dictates of Governor Alex J. Groesbeck (1921–33), who insisted that Jackson maintain its record of having the largest walled prison in the world. The new prison took up 57.6 acres, hence won. As a result, Jackson does, indeed, lay historic claim to the two largest walled prisons in the world.

The prison's construction under Hulbert's management included the wasteful use of building materials. The prison-produced concrete, for example, had to be repeatedly removed and replaced due to improper mixing and pouring. This cost the project millions of dollars more than had been allotted. But Harry Hulbert carried on in his role as head of the prison's construction. Corruption continued, along with payoffs to special interests. Groesbeck, known also as a road builder with the growing advent of the automobile, knew it was desirable to increase the prison population, as inmates would be put to work building roads throughout Michigan.

Harry Jackson, in his various terms as warden, did a good job of keeping matters in order—that is, in preventing uprisings among the prisoners. He, too, however, was implicated in a variety of rule-breaking schemes involving the Purple Gang both at the old prison until it closed and again at SPSM. He was suspected in the Hooper murder and allowed the inmate elite to come and go from the prison, bring in booze and drugs and go to brothels and other venues of pleasure and entertainment.

As one can see, Jacktown's rogues could be found not only among its inmates.

The Contract System, Industry and Distinctive Interaction with the Town

At the end of Mechanic Street stood Michigan's first state prison, glorious with its Greco-Roman architecture and magnificent Administration Building towering five stories into the air. In the era of the "Big House," no attempts were made to hide a penitentiary. A town with such a facility had reason to be proud. Business boomed and thrived on the cheap prison labor. Factories proliferated. By 1882, MSP boasted industries including the following: monument manufacturing, cement making, brick baking, fabric weaving, chair and furniture manufacturing, machine parts, brush production, clay and cookware, cigar making and shoe manufacturing. In addition, thanks to the prison's farms, a canning industry existed that became world famous and would continue at the State Prison of Southern Michigan until the closing of the farms there in the late 1970s.

Another famous industry—the first factory to be built on the MSP grounds—was the Jackson Wagon Factory, founded in 1837. It produced wagons for farms, local taxi use and travel westward. The Jackson Wagon became the first mechanized automobile with two levers: one to go (at three miles per hour) and one to stop. As automobile manufacturing became a reality and slowly phased out wagons, this first mechanized wagon led to Jackson becoming a leader in the new industry with, among other cars, the Jaxon. Inmates went from building wagons to manufacturing cars—that is, until Henry Ford's assembly line made obsolete the individualized, piece-by-piece production of cars.

Above: These farm barns sat on the three miles of farmland running to Loomis Street and along Cooper Street. *Courtesy Jackson District Library.*

Right: This map shows the mini-city of factories and all other buildings within the MSP walls. *Courtesy of Jackson District Library.*

In the days of the wagon, the Jackson Wagon became the most popular means of transportation for pioneers during the 1849 gold rush, and the firm continued to lead other wagon companies (including Studebaker). The Jackson Wagons and carriages were noted for their superior sturdiness. Owned by B.M. Austin, W.A. Tomlinson and Edward A. Webster and known as Austin, Tomlinson & Webster (also as the Jackson Wagon Factory), it was the first factory on the new prison grounds. It had adjunct buildings within the town.

When the initial contracts were signed for an industry to be built on the prison grounds, and as the idea for inmates to work at factories outside the prison walls became a reality, discipline became a major problem. Unlike prison guards or keepers, factory foremen did not enforce the prison's rules. When no guard was on duty in a given factory, the Code of Silence was violated. Inmates talked, discussing any subject they wished. Without the strict supervision found in the cellblocks, mess hall and prison grounds, inmates were prone to walk around and talk at will, take breaks from their work and generally act like free men. During disciplinary crackdowns, the prisoners would often destroy factory-owned property. It might be said that the prisoners were running the store, or as the old adage goes, the lunatics were running the asylum. If their wishes were not met, the convict laborers often sabotaged the factory. In 1852, a fire destroyed the huge rectangular wagon factory built on the prison grounds. A convict arsonist was, indeed, discovered.

This Armory Arts Village mural depicts inmates working at Jackson Wagon Factory. *Courtesy of historian Judy Gail Krasnow; muralists, Hector Trujillo and Jean Weir.*

As a result of the fire, everything had to be rebuilt. Now, the wagon factory stood across from the front of the prison, on the west side of Mechanic Street. The building stands today and is known as ART 634, a collection of artistic shops and home to the Jackson School of the Arts.

Factory owners and foremen quickly realized that rewards produced better, more rapid and more efficient work. This form of supervision also prevented the destruction of property. Many owners offered bonuses to those prisoners who performed their jobs well. Order prevailed for the most part. Then, fifteen years after the fire at the wagon factory, the prison's board of control investigated the practice of rewards, which was not part of official policy. It was determined that, yes, rewards were being given. As a result, a rule was passed that all such enticements were to stop—rewards did not comply with the concept of punishment. At this point, major fires swept through each and every prison-contracted building. Damages amounted to some $100,000, a huge sum at the time. All of the structures had to undergo reconstruction or total rebuilding.

Matters became more punitive within the factories. Quotas became the norm. In the shoe factory, each convict was to complete six pairs of shoes per day. The wagon factory set as a goal the production of seven wheels per convict per day, upping the number from five. Down the line, higher numbers were set, and if the convict didn't achieve the goal, he suffered chastisement with "bad time" on his record. This effort to keep the convicts busy every minute also led to impossible achievements. Yet enough bad time could land the overworked inmate in solitary. It could also cause death by machinery or drive an inmate to suicide.

In Thomas S. Gaines's book about the life of William Walker, a freed slave later imprisoned in MSP, he writes of an inmate, known as Donovan, who commented that a "dead death was preferable to a living one." A few days before his sentence was to expire, he was inexplicably thrown into a pit where a flywheel weighing several tons swiftly revolved. His body was cut into several unrecognizable pieces. Other sharp and whirling machinery caused the loss of fingers and arms, as well as death. In many cases, a piece of an inmate's clothing became caught in the machinery. Thus becoming, in a way, part of the machine, the inmate would be dashed against the walls or ceiling.

Such accidents were not confined to prison labor during the Industrial Revolution. However, the prison factories had even fewer safeguards than did facilities used by the general public, as an inmate's life was basically considered worthless. Demanding the impossible in terms of quotas,

The spinning room in the highly lucrative Binder Twine Factory, established at the beginning of the twentieth century. *Courtesy of Jackson District Library.*

with the alternative being a torturous punishment of one sort or another, increased the number of accidents. In many cases, such accidents resulted in insanity that led to suicide. William Walker, born a slave and having lived as one until young adulthood, claimed that the "slavery" of the contract system in penitentiaries was worse than the actual slavery into which he was born. In his life as a slave, he worked hard in the fields, couldn't get away and was at the mercy of a kind or vicious owner but also had an element of freedom. When the day was done, he could return to his small cabin, be among friends, sit in the open air and sing or dance. As a prisoner, he slept behind locked bars in a stench-filled, disease-ridden space no man could endure.

Walker did not praise any form of slavery, but he claimed that the prison contract system was the worst form of slavery. As an owned slave, food and clothing were provided. Under the contract system, the rich factory owners grew more wealthy, while those doing all the work could not support their families or purchase sufficient food and clothing. This caused the government to have to pay welfare to the wives and children of the incarcerated, due to the pittance of a wage given for convict labor. Hence, Walker said, it was an expense for the state while enabling those with great wealth to become even wealthier. To quote Walker: "The state has to look

after the welfare of more than a thousand women and children, for the simple reason that their main supporters are here in prison and making a fortune for a ring of contract kings."

Arguments made in favor of the contract system included the following: inmates had work to do; they learned skills; they earned money; at the end of a day, they could feel a sense of accomplishment; and they would get a good night's sleep. The contract system was questioned periodically, such as during the recession of 1887. Michigan passed a law in 1909 forbidding the production of goods by factories at prisons in towns that had competing factories. The belief purported that nonprison industries would better serve the population by hiring nonconvict workers. Now, prisons could only house factories that produced goods not made in its town and elsewhere in Michigan. This left operations such as the Binder Twine Factory safe, for it only existed within the prison walls. One problem with this new situation was that inmates who learned skills pertinent to a prison factory would, on being released, possess skills that could not be used at factories existing within the town and state. And, adding to their dilemma, they could not

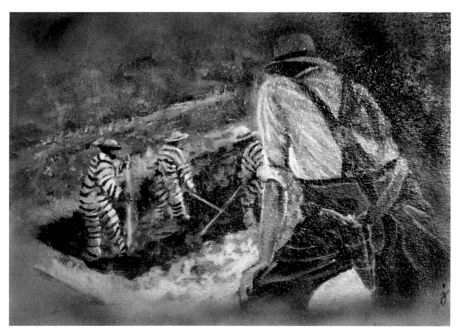

Inmates at work, with an armed guard watching. *Courtesy of photographer Jon Tulloch; muralists, Hector Trujillo and Jean Weir; historian, Judy Gail Krasnow.*

travel outside of Jackson or Michigan. More and more, goods produced for state-run purposes replaced the former private factories. After the 1929 stock market crash, matters became worse as unemployed people on the outside resented the fact that inmates still had work, a roof over their heads, a bed to sleep in and three meals a day.

Today, lack of sufficient work on the inside has created the problem of boredom. The only work allowed in Michigan's prisons is manufacturing for nonprofit and state organizations. This does not provide enough jobs and worktime to keep the many incarcerated men and women busy. Boredom breeds unrest.

THE HEYDAY OF THE CONTRACT SYSTEM

As a result of its factories and convict labor, Jackson became one of the leading industrial cities in the United States. With the advent of the Jackson railroad station, built in 1873 and serving as the hub between Detroit and Chicago, two major industrial cities, goods produced at the prison could be shipped far and wide. Among products produced at MSP were gowns minus buttons, elastic or zippers made from fabric manufactured at the prison and of such sturdy quality that they provided inmates in asylums safe clothing that could not be torn or used for suicidal purposes. Rolled cigars were shipped to tobacconists. Canned goods were not only transported by rail but also sent overseas via ships. Jackson's cemeteries are filled with monuments and tombstones made at MSP by the inmates. Beautifully crafted wooden furniture with "MSP" carved in them decorated homes throughout Michigan. Brooms of all sizes and shapes, used to clean everything from household corners to general stores, were manufactured at MSP.

Three mines discovered in the area in the early 1870s and mined by inmates at Jacktown provided coal for many a furnace and locomotive. The following rather humorous story—humorous in retrospect—is a legacy from the coal mines.

Some prisoners caused trouble at night, breaking the Code of Silence either by shouting to other inmates after a night keeper had finished his rounds of a cellblock and gone on to another or by loud snoring. For these chronic disruptors, night-shift work in the coal mines seemed a fit punishment and solution to the disruption problem. Several inmates worked the night shift, and many worked there during the day. Then, thirty-three inmates disappeared shortly after beginning their work in the mines. The reason for

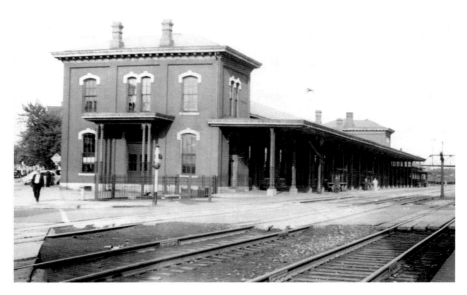

The Michigan Central Railroad depot was the hub between Chicago and Detroit. Today, it is the oldest still-standing and operating railroad station in America. *Courtesy of Jackson District Library.*

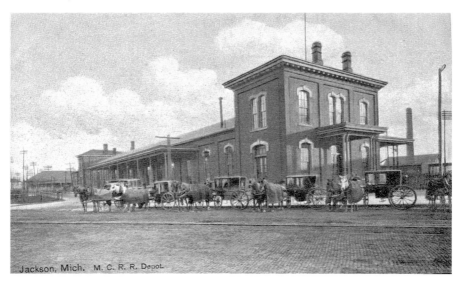

Horse-drawn carriage taxis are seen at the railroad station, the hub between Detroit and Chicago. Al Capone often escaped from the Jackson police at the station. *Courtesy of Jackson District Library.*

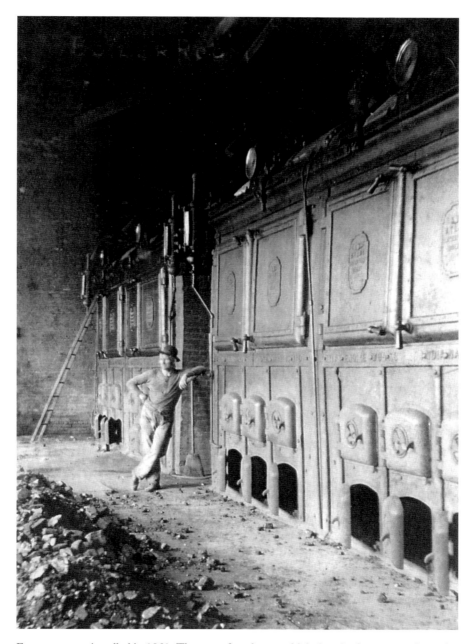

Furnace room, installed in 1861. The cost of coal was so high that the furnace was heated for only three hours on the coldest winter days. *Courtesy of Jackson Historic Prison Tours.*

the strange disappearances—or escapes—was not caused by any accidents. The situation was eventually resolved. A hole in the mine, narrow and claustrophobic, finally came to light when an inmate who was promised a shortened sentence and protection showed the officers the escape route. The hole, through which the inmates wriggled their way to freedom like worms crawling through the ground, led to a stream and into the huge oak forest. A distributed pamphlet and signs advertised the names of the escapees, and most of the thirty-three were returned to their cells, with longer terms added to their sentences. Some of the escapees were not found. Needless to say, the hole was sealed.

THE TOWN AND PRISON INTERACT

Looms in the prison factories produced beautifully woven fabric. The prison tailor shop, noted for its outstanding quality of workmanship, brought mothers from the surrounding areas of Marshall, Ann Arbor, Albion and Napoleon to have their daughters' wedding gowns fitted and sewn. In town, a prison goods store sold many items, including fabric and clothing, furniture, canned goods, rope, dishes from the prison clay factory and other items made by the inmates of MSP. Shops along Main Street sold prison-made goods. Elsewhere, farm implements purchased throughout the nation were the handiwork of prisoners working for the famous Withington & Cooley Factory.

Events took place at Jacktown that were unknown at other prisons. Many talented musicians were incarcerated at Jacktown, particularly during Prohibition, when, in police raids, bands playing at speakeasies were arrested. MSP had a prison band practically since its inception. A bandstand was built outside the mess hall. On weekends, the huge iron prison gates were open to let the townsfolk in. Dressed in their Victorian finery and carrying picnic baskets, they entered the prison yard in order to be entertained by the renowned band. Each year, the band played at the much-anticipated watermelon festival. There, to the music of the band, the succulent watermelons grown on the prison farms were joyfully eaten.

Perhaps one of the strangest occurrences happened at Thanksgiving each year. The prison band members, bedecked in their band clothes—special uniforms worn while playing, in place of the suits of black and white stripes—were released with their instruments in hand to march down Main

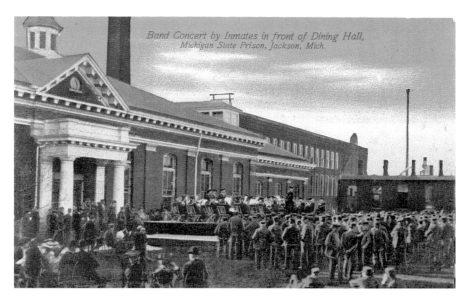

The prison band gave concerts outside the mess hall. The prison gates opened as the townsfolk poured in for the annual watermelon festival. *Courtesy of Jackson District Library.*

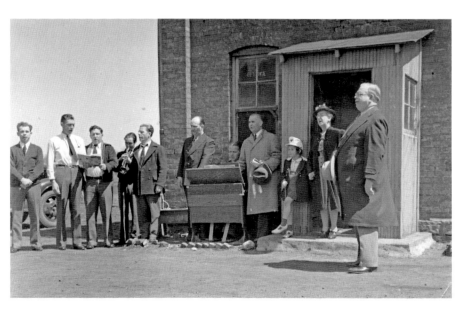

Prison musicians warm up the band for the Thanksgiving parade. Warden and Mrs. Harry Jackson and the chaplain give a blessing. *Courtesy of Josephine Ellis Smith.*

Street (now West Michigan Avenue) to provide the music for the yearly Thanksgiving Day Parade.

The prison also had a baseball team, known as the MSPs. The town of Jackson had its own team, the Clippers. The MSPs, of course, only played home games, and the Clippers and other teams played against the MSPs. As with the prison band, the prison team wore special uniforms for this activity. Cleats and belts—potential weapons—were forbidden. The MSP uniforms took this into account, and the prison players got used to running either in their off-sized prison boots or in bare or stockinged feet. The Clippers, playing frequently against the MSPs, also got used to these restrictions. Recently, a very elderly man visited the old prison, now repurposed as a residence, Armory Arts Village. He was a young boy when the prison was still open. In a scratchy, squeaky voice, he told this author the following:

> *When I was a young little tyke, my daddy used to play for the Clippers. Every darn time he'd come home from a game here on these old prison grounds he'd put his arm around my shoulders and say, "Son, I tell you, those prison baseball players are good, real good son, too good! Every time we Clippers play against them, they whup our butts!"*

The prison gates were opened to allow residents to watch the town's Clippers play the MSPs. The young fellow in front is a child prisoner. *Courtesy of Jackson District Library.*

One time, a team from Canada came to play. Before entering the prison grounds, they had to remove their cleats and belts. The game proved quite amusing as they slipped and slid in their bare or stockinged feet. As they ran, they held up their pants in order to keep them from falling down, which did indeed happen when the players let go to slide into a base.

By the time MSP closed in 1934, the state had its own prison commissioner of baseball, Walter "Bo" Slear. Boxing, wrestling and basketball had been added to the sports played by prison teams. Following the tradition of MSP, sports continued at the new prison, SPSM, and even produced a Detroit Tigers great: Ron Le Flore, who went from stealing and incarceration to stealing bases. The sports and other interactions with the town of Jackson continued until the late 1970s, when the murder of the Mroz family by two Jackson inmates who had wandered away during their work on the prison farms created a change in attitude. The two prisoners might have gotten away with murder. However, on returning to their cells, they stuffed the jewelry they stole from the family in their toilets. At lockdown, all inmates had to flush their toilets during the officers' rounds. The jewels plugged the toilets of the two murderers. The plunging brought up the evidence. This murder and changing times in general put an end to prison/ town sports competitions, as well as the annual concerts attended by townsfolk in the beautiful auditorium at the State Prison of Southern Michigan, which replaced MSP in 1934.

In addition to the murders, another factor had a role in the new attitude regarding prison/town relations. The United States began a new era in economics. Foreign goods, including produce, were sold at far lower prices than American-made goods and produce. These items now filled stores and markets. This affected farming at the prison. The self-sufficiency of MSP that

As seen on the cover of *The Spectator*, Walter "Bo" Slear was the manager of the MSP baseball team. This sketch was made by inmate A.G. Thomas (No. 5780). *Courtesy of Michigan Historical Museum Archives.*

had continued at SPSM came to an end. A former director of the SPSM farms told this author how the prisoners wept at the sight of the cows, pigs and other farm animals as they were forcibly placed into trucks headed to auctions or slaughter.

During the time of MSP, when interaction between the prison and town was at its height, food played an important role. In 1893, at Jacktown, townsfolk freely delivered all sorts of delicious morsels to their loved ones within the prison walls at holidays. Guards busily distributed the welcome food. Marquette State Prison had opened in 1889. Its relationship with Jacktown became a human Ping-Pong game. Unruly inmates at Jackson ended up being sent to Marquette, known as the "Siberia of the North." When a transferred inmate grew unruly at Marquette, he'd end up back at Jackson, known as the "Country Club of the South." A competitive incident between the two prisons involved special food at Thanksgiving. Warden John N. Van Evera at Marquette had his hands full when the inmates heard about the goings-on at Jackson. Evera followed the edict from Lansing, part of the Public Acts of 1893. It stated:

Whereas the State provides the inmates of the three prisons [Ionia, Marquette and Jackson] *with proper and sufficient food, and the*

Ornate tin tiles make up the ceiling of the mess hall. Breakable, sharp ceramic dishes were ultimately replaced by stainless steel ones, also dangerous because the edges could be sharpened with use. *Courtesy of Jackson District Library.*

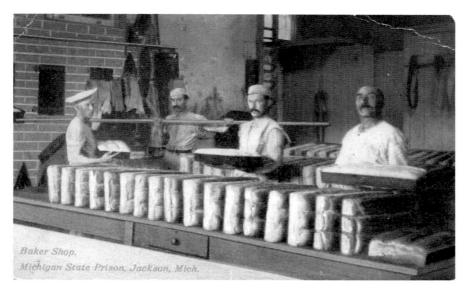

The prisoners did the cooking. Some are seen here in the baker shop, which was in the kitchen of the mess hall. *Courtesy of Jackson District Library.*

admission of extra food coming into the prisons is attended with many abuses and hurtful to discipline, therefore, it is hereby provided that no food be hereafter allowed convicts other than that provided by the State: Unless for good reasons, the board shall otherwise allow in special cases.

It is interesting to note that if a prisoner's stomach is full, chances of an uprising diminish. Leniency at Thanksgiving and other major holidays at Jacktown helped keep matters under control. Food plays a vital role in prison, and three meals a day provided a gratifying activity when there was little else to fulfill an inmate's life. Almost twenty years after the old prison closed and was replaced by the State Prison of Southern Michigan, the worst riots to date in American prison history broke out at Jackson in 1952. After millions of dollars of damage, brutality among the inmates and the taking of hostages by the instigators—two mentally disturbed inmates, Earl Ward and Crazy Jack Hyatt—the mediation of a heroic guard, Harold Tucker, ended the riot, with the governor agreeing to feed the inmates a prime steak dinner with ice cream as dessert.

A WAGON FOR AN ELEPHANT

As William Walker stated in the book *Buried Alive*, the contract system was, in some ways, a worse form of slavery than the actual institution of slavery. But some amazing items were produced in the factories. In the late 1800s, the Jackson Wagon Factory received a telegram from a man known around the world, P.T. Barnum, of the famous and beloved Barnum & Bailey Circus. Circuses were greatly anticipated events in both small towns and big cities. What entertainment they provided! Carnies barking their goods; lion tamers encaged with those wild cats; dogs dressed in outfits fit for kings and queens; clowns with their teasing antics; beautiful acrobats on dazzling, sparkling horses contorting into almost unimaginable shapes; men on tall stilts; and singers, dancers and jugglers. Also featured, in an era less understanding of people with unusual maladies, were participants in "freak shows": Siamese twins (as conjoined twins were then called), bearded ladies, people weighing six hundred pounds, midgets and dwarfs. The entire entourage traveled from place to place via trains, entering towns with a parade in a gala procession. Throngs of people gathered along the route, thrilled that the circus had come to town and eager to go to each and every offering as it opened.

In 1889, the most famous star of the Barnum & Bailey Circus had been around for years. Initially rescued from a London zoo by P.T. Barnum as a young critter that had suffered brutal, abusive and inhumane treatment, this creature became beloved around the world. The remarkable star was Jumbo, a thirteen-thousand-pound elephant that stood nearly fourteen feet high. In 1889, Jumbo was old and growing feebler. He simply could not walk the long miles of the circus parade.

The telegram sent by Barnum to the Jackson Wagon Factory requested that the factory build a wagon big enough and strong enough to carry the huge, weighty elephant through the towns and cities the circus visited. The factory accepted the challenge, trusting that its wagons, which had carried so many across rugged terrain going westward in the gold rush, could be modeled to carry an old, huge and heavy elephant.

The inmates of MSP were set to work. The wagon was constructed within a few months with, of course, the logo and these words painted on it: "Jackson Wagon since 1837, Jackson Michigan." The big, tall wheels were wrapped separately when the wagon was hauled onto a ship heading for London, where the circus was soon to appear. Reassembled on arrival, it held the huge elephant nobly. The tall wagon was built to allow much of Jumbo to be exposed to the crowds that swarmed around to see the elephant,

Jumbo, too old to walk in a circus parade, was wheeled in a huge Jackson Wagon, made by inmates. *Courtesy of Jim Guerriero and photographer Jon Tulloch.*

One of the famous "Jackson Wagons." Illustration courtesy of Jackson Public Library.

It Put Jackson "ON THE MAP"

PUBLIC LIBRARY
JACKSON, MICH.

By the 1850's, Jackson was doing nicely as an up-and-coming Michigan community, but was virtually unheard of outside the state.

Yet a few years later, it was a name familiar to the entire country, thanks to its first "home" product to win national acclaim — the doughty "Jackson Wagon."

Jackson Wagon, manufacturer of the top-selling wagon in the nation, used inmate labor for contractor Austin, Tomlinson & Webster. It was Jackson Prison's first factory. *Courtesy of Jackson Historic Prison Tours.*

which extended his trunk to "shake hands" with the cheering people. The Jackson Wagon carried Jumbo through London, Lisbon, Paris, New York, San Francisco and other great cities.

Jumbo met a tragic death in St. Thomas, southwest of London, Ontario. While crossing the tracks on the way back to the circus train, an unexpected locomotive roared by and hit Jumbo, sending the huge elephant flying and demolishing the engine while derailing the train. It is said that P.T. Barnum cried virtually nonstop for a week for his beloved Jumbo and that Jumbo's trainer lay by his side holding his trunk and weeping for the whole day and night as the elephant awaited proper removal. Jumbo's preserved bones compose an intact skeleton at the American Museum of Natural History in New York City.

WOMEN IN MICHIGAN'S
FIRST STATE PRISON

When Michigan's first state prison opened, it was the only one. If a woman committed a crime and was convicted, she was sent to the state prison. Initially, the men and women inhabited cells in the same area. This created many problems. Interestingly, a major one involved women's menstrual cycles. With no plumbing, only a honey bucket, no sanitary napkins and total lack of privacy, it became evident shortly after the construction of the West Wing that women must have separate housing. With the new arrangement, among other things, the rags used during menstruation could be washed and hung in the privacy of the women's quarters.

A brick building constructed in the prison yard stood near what eventually came to be known as the Annex. It initially housed ten women and, later, approximately thirty, the maximum number of female inmates in the prison at any given time. Several of those convicted were serving long or life sentences. The most common crimes for which women were arrested were excessive inebriation (chronic excessive drunkenness), prostitution, theft, robbery and, in a few instances, murder.

Hired matrons worked on shifts as the "keepers" of the women. Women did not work in the factories. They cleaned the prison, including the men's cellblocks. As the prison grew and the East Wall was added, quaint row houses were erected and lined the outside of the wall. The upper echelon of employees at the prison lived in them. The female inmates who provided domestic work for those living in the row houses were led through the tunnels built under the prison grounds and out through the prison gate.

They laundered, cleaned and, in some cases, cooked. A few select women worked as domestics for wardens.

Three names continually pop up when researching women in MSP. They are Mary Ellen Rouse, Sarah Haviland and Mary Baker. Baker murdered her three children in Battle Creek. Little is written or known about her. She served a life sentence. There is, however, more recorded history about Mary Ellen Rouse and Sarah Haviland.

MARY ELLEN ROUSE

Through the Jackson Historic Prison Tours established by this author, Henry Roberts contacted us from Canada and ultimately visited, taking the tour. He sent the following letter:

> *Judy and Newly Found Cousin from Indiana, Linda Novotny (also related to Mary Ellen Rouse),*
> *First, let me thank you for the wonderful trip through the prison that Mary Ellen Rouse, my 2ⁿᵈ great-grandfather's sister, was incarcerated in during its early years. I have always felt a connection to her....Mary obviously was attempting to escape a bad life at the hands of her family. She was in an Eaton Rapids jail in 1864 and had escaped and been on the run about a year before her capture and trial in November of 1865. At that time in November, she was put to trial and convicted for Larceny including theft of her brother, Frederick's deed of property that she stole and sold for $100 from the safekeeping of their father. She sold her brother, Frederick's deed in his absence while he served in the Civil War in order to likely move away; as we learn by way of newspaper articles, she was pregnant.*
>
> *We know by way of newspaper articles that she gave birth to a child "just months" after incarceration in 1865, which gives an early date of the first quarter of 1866. My hopes are that her files regarding her original incarceration in about 1864 can be obtained as she spent time in the jail of Eaton Rapids. She obviously escaped the Eaton Rapids jail and then went on a crime spree, culminating in her capture and trial in November of 1865 for not only stealing and selling her brother's deed of property but for several other thefts....The birth of a child in prison walls seems like it must have been reported somewhere. Another point in question is if Mary Ellen had any visitor logs...family or friends.*
> *Yours Truly,*
> *Henry*

Newspaper articles tell the story of Mary Ellen Rouse. Her prison papers give her birthplace as Ohio. According to the records, her hair was light brown, her eyes were light hazel and she had a two-inch scar on the inside of her left hand near her thumb. Several articles appeared in many newspapers reporting her escape. They all claimed the following.

1. *She had been convicted of larceny in Eaton County and sent for a term of two years and eight months to the Jackson Prison.*
2. *Her time would have expired on the next March 7.*
3. *Only a few months after she was imprisoned, she gave birth to a child (the gender not mentioned); the child was kept with her in the prison until sometime during the summer prior to her escape; the child was taken by relatives of the mother who lived in Eaton Rapids.*

She apparently could not bear the separation from her child and plotted her escape. The matron keepers kept their uniforms in a closet in the women's quarters. Each matron had her own uniform and would, upon entering the prison, remove her civilian clothing and don the uniform. Just before a shift change, Mary Ellen stole and put on a keeper's black silk dress, earrings and other articles. The total outfit was valued at $150. Dressed in this attire, her hair hidden under the keeper's bonnet, Mary Ellen simply walked out before the matron keeper returned to change back into civilian clothing. Mary Ellen walked through the gate, where the guard took her for the employee whose clothing she now wore.

After Mary Ellen Rouse was discovered missing, signs were posted in bold lettering:

ESCAPED
$50 REWARD
Michigan State Prison
Jackson, November 7th 1867
ESCAPED from this Prison, last night, convict
Mary Ellen Rouse, aged 20, light complexion,
Pleasant face, even teeth, hair inclined to curl a
little, short in stature, fleshy, and had a scar
on the inside of her left hand.
Whoever will return valid convict to this Prison
will receive the above reward.
Notice
H.H. Bingham, Agent

Mary Ellen escaped to her father's home in Eaton Rapids, hoping to reunite with her child. Sadly for her, she was arrested immediately after arriving at the house. She never saw the child, as it had been sent abroad in the care of a sister. Mary Ellen was returned to prison, and her sentence was extended for the crime of escape and theft of the matron's clothing. The number of years added to her incarceration is not recorded. It is not known if she ever saw her child again. To this day, her relatives hope to find out what became of her child, whether it was male or female and, if the lineage goes on, the names of any descendants.

SARAH HAVILAND

Sarah Haviland's story is quite different from Mary Ellen Rouse's. Instead of longing for her child—in her case, children—she murdered all three in Battle Creek in 1866. Haviland never caused trouble while in prison. Throughout her thirty-plus years of incarceration, she was well liked and respected by wardens—she worked as a domestic for them, cooking, cleaning, sewing and even babysitting! Those who knew her affectionately called her "Aunt Sarah." As time went on, she proved her trustworthiness and, as a result, was awarded the privilege of occasionally shopping in town, as though she was an actual servant, not an inmate. Frequently, she was driven to town in the prison carriage by another convict. She never attempted an escape, and she is known to have prevented two potential escapes by sounding the alarm.

Ultimately, at the suggestion of several wardens for whom she had worked and longtime prison chaplain George H. Hickox, she was pardoned. She was nearly seventy years old and in declining health. One report says she went to live with her daughter in Tecumseh, Ontario. However, since she had murdered all of her children, that could not have been the case. Another report states that a distant cousin was located and took her in. Haviland died a free woman at last.

There are conflicting stories about just what caused Sarah Haviland to murder her children. It appears that the father of her children abandoned them. To be a single mother with no help or support was not viewed with sympathy in Sarah's day. Unless a widow was provided with an inheritance, she could barely make ends meet. She would have to work in a factory twelve hours a day, six days a week—or, worse, join the "world's oldest profession," prostitution. In either case, chances were high that her children would be taken from her and placed in an orphanage.

One story has it that Sarah Haviland had a lover, a doctor named Dan Baker. Sarah and another female inmate, named Mary Baker, also from Battle Creek and who also had murdered her three children, are often confused with each other. This is an obstacle for someone trying to piece together the bits of history pertaining to individual inmates.

Perhaps it is the Baker name that causes the confusion. Dr. Dan Baker practiced clairvoyance. In later years, Sarah supposedly claimed that her crime was committed while under a hypnotic spell cast on her by her clairvoyant lover. The story goes that the doctor had promised to marry her but claimed that her three children were in the way. This account states that she killed the children and that he made the burial boxes after their deaths. Sarah got life in prison for such a heinous crime. Baker, supposedly convicted as an accomplice, died in prison three years after his sentencing.

Her Scottish lineage, likeability, peaceful nature and unblemished record while incarcerated make another story about Sarah Haviland highly possible and, perhaps, more believable. Put into verse by this author, the tale goes as follows:

The Ballad of Sarah Haviland

I, Sarah Haviland, for three children could not care.
My husband had long left me, and alone I could not fare.
They were so terribly hungry I felt nothing but despair;
So, I got me some arsenic, sat each child in his chair.

Then I stole me some chickens and I cooked up quite a treat.
They gulped it down so heartily, my heart skipped several beats.
Then there, right before my eyes, my children oh so sweet
Convulsed, gave up the Ghost and lay dead at my feet.

Oh, Lord, dear Lord, now I felt so weak.
Oh, Lord, dear Lord, first so bold, and now so meek.
Oh, Lord, dear Lord, what did I do?
My poor, hungry children, I thought death would rescue you.

I carried them down to the creek where they had loved to play;
Where someone saw me drop them in then quickly run away!
At home that night all wrapped in fear as in my bed I lay,
The officers to Jacktown shackled me away.

I cried and I cried, and to them I said,
"My poor hungry children are better off dead.
Why, up there in heaven, there's more than food to spare."
The iron prison door banged shut. In Jacktown they don't care!

I quickly learned in Jacktown how survival's rules to play.
I cooked and cleaned for wardens; even babysat each day.
Why, I was such a good housekeeper that came my dying day,
The governor gave me a pardon, and sent me on my way.

Oh, Lord, dear Lord, is it Heaven for me?
Or will I burn in Hell for Eternity?
Oh, Lord, will I ever see my three children again,
Whose hunger got me locked for life down in the Jacktown Pen?

Yes, my name is Sarah Haviland, and children I had three.
I murdered each one of them in a desperation spree.
They were so miserably hungry—truly, I thought death would set them free.
I freed them, but it was Jacktown and a prison cell for me.

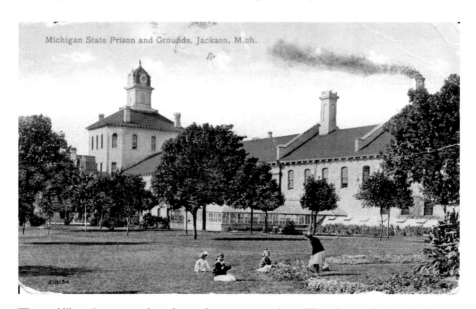

The parklike prison grounds and greenhouse are seen here. There is speculation that the woman shown here may be Sarah Haviland, with the warden's children, as dates match when she was imprisoned. *Courtesy of Jackson District Library.*

WOMEN GAIN A PRISON OF THEIR OWN

In 1861, it was decided that having separate, dedicated prisons for men and women would be a better way to administer their incarceration. That year, the Women's House of Detention opened in Detroit. Known also as the Detroit House of Corrections, it had separate areas for women and men. It was, in effect, two prisons—one for men and one for women. This was unlike MSP, where, in spite of separate living quarters, all prisoners were under one roof, eating together and mingling.

It wasn't until 1880 that all women incarcerated in the Jackson prison went to Detroit. The women's role in MSP was still under debate—how useful were they in Jacktown? After all, the women cleaned the prison and did other chores not performed by the men, who provided the factory labor. A letter sent in 1867 to the Honorable Henry H. Crapo, the governor of Michigan, and signed by three state-appointed prison inspectors, states the following:

> There are now 24 convicts in the Female Department of whom 4 are sentenced for life.
>
> Of the whole number 4 are habitually invalids, so as to prevent the State deriving much benefit from their work.
>
> Four are employed doing household work for the Female prison.
>
> Two are employed making cane chair seats, earning on the average $55 a month.
>
> Five are employed making and mending clothing and bedding for the male convicts (say 500 men).
>
> The general health and condition of these prisoners are good—excepting some badly diseased, and 4 others more or less so from immoral habits previous to imprisonment. None of them, however, so as to be disabled from employment. The discipline is good, the prisoners cheerful, and their deportment visibly improved by their stay here.
>
> It would require the work of perhaps 10 men to do the work for the male convicts, now performed in the Female Prison, if continued to be done by convicts—in case the females be removed. Or, if done by hired free labor, the expense would be very considerable.
>
> In the opinion of this Board, the work of the Female convicts supports them taking into consideration what it will cost to replace their services, in case of removal.
>
> They are all opposed to being removed to the Detroit House of Corrections.

If the law provided for a transfer of all the Female prisoners, so that this Institution could be altogether relieved from their care and support, it might be desirable to have it carried out; but in as much as the life convicts must continue to be incarcerated at the expense of the State, together with that of a person to keep charge of them, this Board does not believe it would be for the interests of the State to make the contemplated removal, but that it would rather curtail an addition to the cost of maintaining the State Prison, over which required under existing arrangements.

Some women were removed from MSP, but it was not until 1880 that all of them were gone. MSP did not accept new female prisoners. Those went to Detroit. Only one woman remained until the late 1890s. That woman was Sarah Haviland.

THE PENDULUM SWINGS

From Punishment to Reform, Education and the Arts

Throughout Jackson's prison history, the pendulum has swung, from sheer punishment and the demeaning and humbling of inmates to rehabilitation using discipline and respect for the human being, in spite of his or her crime. In the 1860s, until the trial of John Morris, brutality and belittling were the norm. Reformer John Purves entered the scene and put forth the radical concept that if a man receives only punishments, he has no incentive to improve himself. People need rewards, something to aspire to—being good brings good things. His *Night Keeper's Reports* of 1882 became a guide for this concept of treating inmates. Published in 1917, the reports became required reading for those training for employment in prison.

In 1885, H.F. Hatch became warden. Known as the "reform warden" of MSP, he had many visionary ideas regarding penology. While wardens were appointed by political cronies based on donations to a gubernatorial or Senate race, Hatch maintained that politics should remain out of prisons, and prisons out of politics. He felt that the criminal justice system was filled with complicated and unnecessary rules, regulations and bureaucracy. Rather than fixed sentences, he firmly believed that all men convicted of a crime should be granted indefinite sentences and paroled accordingly when they adjusted to the requirements of free society.

Hatch also fought for the Bertillon system of identifying criminals. This system, developed by a French police officer in the mid-1800s, identified criminals based on their physical measurements. Bertillon also began the

use of mugshots. Until then, criminals could only be identified by name and general photographs. Later, fingerprinting replaced these methods, and today, DNA serves a major role in identification.

Hatch also began a major program of education. He believed that a lack of education was a frequent cause of criminal activity. If an inmate came in uneducated, that same inmate, on receiving an education during his incarceration, would be released with far more possibility of employment and, hence, far less possibility of committing crimes. Most of the inmates had no schooling beyond the third grade. Someone with a fifth-grade education was considered fairly well educated. School became part of the prisoners' daily lives. Illiterate prisoners were allowed to recite their lessons to those inmates who were literate, who would then write them down for the illiterate, allowing them to at least utilize their thinking and speaking skills. William Walker, in *Buried Alive,* narrated his story to Thomas S. Gaines. It is not known whether Gaines was a prisoner or a teacher, but the book that grew out of this narration was encouraged at the MSP education classes. The book, still in print today, is one of the most informative pieces of history about life in MSP and about the contract system.

Many thought that Hatch was coddling those who had broken the law. They believed that his policies would do away with the use of fear as a deterrent to breaking the law. Hatch responded as follows: "If the principles are true, they will survive and will be strengthened by opposition. If they are defective and wrong, they will fail as they ought."

By the end of the 1800s, striped uniforms, considered another form of humiliation, were no longer worn. Many other changes occurred. The West Wing cellblock was updated with new, albeit still small, cells. The invention of the electric light bulb enabled the installation of a primitive lighting system to replace the oil lamps. The school was in full swing. In 1909, the law ending the contract system led to hours of idleness for many inmates. Idleness breeds boredom and violence, and it played a major role in the prison riots that broke out at MSP at the end of 1911 and the resulting presence of the Michigan National Guard well into 1912. Members of the National Guard were housed in tents installed on the lawns of the row houses outside the east prison wall. Townsfolk were warned to stay inside, and schools and businesses were closed. However, curiosity and concern brought crowds to the prison walls to find out what was happening. Newspapers came out only twice a day—what went on between early morning and 5:00 p.m. was of great concern to the Jackson citizens.

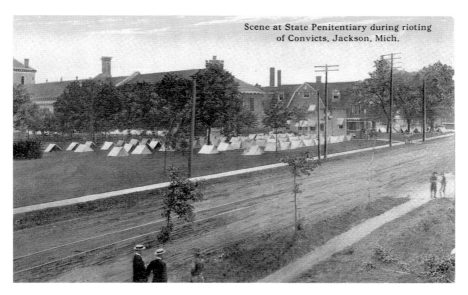

Michigan National Guard tents were set up outside the prison wall during the 1911 riot and for nine months after during cleanup and repairs. *Courtesy of Jackson District Library.*

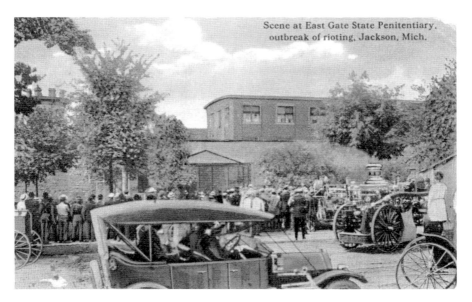

In 1911, a riot erupted at Jacktown. Townsfolk, warned to remain at home, gathered to watch in both fear and curiosity. *Courtesy of Jackson District Library.*

Overcrowding, lack of work and a major rebellion against the Code of Silence were at the root of what was considered the worst prison riot of its time in America. Ninety inmates sawed through iron bars and overran the mess hall, wielding the heavy, deadly weapons. Six people were killed: four inmates and two guards. A third guard, as this author learned from his great-grandniece, had his thumb bitten by a syphilitic inmate and died a slow, torturous death over many years as a result.

After the riot, efforts were made to provide other forms of work and curb boredom caused by idleness. The Binder Twine Factory expanded and supplied twine across the nation. Likewise, the canning factory increased its production. The advent of the automobile in the early 1900s led to prisoners making license plates. A creamery and soap factory were established.

State representative Charles Folks was instrumental in the passage of a law that allowed the sale of crafts made by prisoners to the public, inspiring the inmates to spend what would otherwise be idle time creating products and earning income from them. Albert M. Ewert, appointed chaplain of Michigan State Prison in 1933, further promoted this idea.

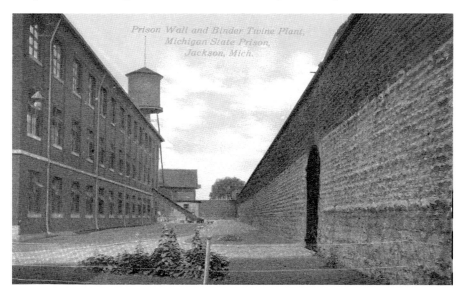

The Binder Twine Factory stood at the north prison wall. It was one of the few remaining prison factories at the end of the era of commercial prison industries. *Courtesy of Jackson District Library.*

In his few years in this capacity, he contributed significant changes, including cleaning up the decadent reputation caused by his predecessor, brothel owner and drug dealer William Hopp.

Chaplain Albert M. Ewert

Albert M. Ewert was a principled man of several artistic talents, including painting, music composition and writing. He wrote many hymns that were transcribed and published as sheet music and numerous papers and other dissertations on rehabilitative methods of treating prisoners. He also became a columnist for a Grand Ledge newspaper. In his column, "The Devil's Advocate," he hoped to open people's minds and make them consider all sides of issues.

The
SPECTATOR
MICHIGAN STATE PRISON, JACKSON

April 13, 1934 Numb

Albert M. Ewert, last chaplain at MSP, believed that the arts were rehabilitative. He taught painting and writing and held monthly meetings with inmates. *Courtesy of Catherine Ewert Benson.*

As chaplain, he truly believed that treating inmates with dignity and respect and giving them responsibilities and the opportunity for creative expression were the ways to return them to society as productive, useful citizens. He believed that circumstances such as the Great Depression and the collapse of the economy fostered criminal behavior. People were jobless, homeless and hungry. Those whose thievery or other actions were prompted by these conditions and ended up behind bars would not benefit from being made to feel even more unworthy and desperate. The inmates should be able to elevate themselves in all ways possible, rather than being turned into true criminals through demeaning and punitive measures. The arts could help foster constructive feelings and allow an inmate to express the experiences that led him to commit the crime that led to his conviction.

Ewert established an art studio and taught painting. Inmates who never had

The Spectator was one of the oldest prison publications in the nation. Inmates wrote and illustrated it. This image is by inmate A.G. Thomas (No. 15870), a very talented artist. *Courtesy of Michigan Historical Museum Archives.*

the opportunity to delve into their potential artistic talent discovered hidden abilities. Some showed genuine professionalism. Their art illustrated the pages of one of the oldest prisoner publications in America, *The Spectator*. Some entered a contest at the elite Grand Central Gallery in New York,

This illustration in *The Spectator* is by A.G. Thomas (No. 15870). The publication was created under the art program of reformer chaplain Albert M. Ewert. *Courtesy of Michigan Historical Museum Archives.*

which, for the first time, held an exhibit of prisoner art. First and second prizes went to two inmates of MSP. Another prize went to a woman at the Detroit House of Detention.

Perhaps the sermons of Chaplain Ewert, his meetings with inmates, his encouragement and trust that they could change their ways were in part responsible for these artistic successes. Inmates wrote letters of thanks, such as the following:

Dear Sir:

Your sermon of this morning was undoubtedly one of the best sermons which has ever been preached from the rostrum of our chapel. Strictly fundamental in every respect, filled with real wisdom, and it is my candid opinion that only a real disciple of Christ could deliver such a message.

Dear Sir:

I want to be the first of the inmate body to congratulate you upon winning the hearts of the men, by your fine address on Sunday morning.

Most of the 800 or 900 men who came out to Chapel Sunday, came to "see what the 'New Holy Joe' was like," and stayed to be won over, heart and soul, to the new Chaplain; a man, and a sincere speaker.... More power to you...that you come to know us as we really are; loyal, sincere and respectful to any man who can command loyalty, sincerity and respect, but intolerant toward hypocrisy and deceit from anyone, be he free or imprisoned.

Dear Sir:

In the nineteen years I have been a resident of our "walled village" I never saw any prison official take the method you have to get closer to the men who look to you as a friend and I again want to offer my appreciation and assure you my whole hearted co-operation if it is ever within my power to extend any kind of service to you.

Dear Sir:

I have witnessed too much brutality.... Yes, indeed, and hundreds of men in the asylum for criminal insane are living monuments [of this behavior of a brutal warden and corrupt chaplain].... *Our new Chaplain has restored our faith in God.*

Writing was encouraged, whether in the form of poems, essays, humor or short stories.

Inmate Harry Evans (No. 20679) became known, via his nickname, "John Blood," as the poet laureate of Jacktown. Serving a fifteen-year sentence for larceny and check forgery, he was released after seven years and never returned to prison. He discovered the poet within himself. Perhaps this form of expression promoted his early release and good life thereafter. The following is one of his writings:

Thomas Jefferson—Democratic Apostle

Down from Virginia's hills there came
A lad, whom we to-day, acclaim—
A former tiller of the soil
Whose upright character and toil
Made of this rugged, farmer's son
A man like unto Washington—
In that, though blessed with wealth at birth,
He loved the lowly ones of Earth;
And strove in ev'ry way he could
To raise the standards of manhood;
And such a man was sure to gain
The heights he'd striven to attain;
Thus, Justice, more than kindly Fate
Sent him to sit in halls of State
On council boards of strategy
That planned the war for liberty.
Behind all armies there must be
Some soldiers whom few know or see—
They have no guns—nor do they wield
Swords—but in their ordained field
They may more victories acquire
Than those who brave the cannon's fire;
For neither arms nor fighting man
Could win a fight without some plan
Of battle—for as troops advance
Nothing must be left to chance;
And all such plans must emanate
From councils, held by men of State—
Far sighted men of thoughtful mien

The jokes in various issues of *The Spectator* illustrate how humor differed in the early 1900s. *Courtesy of the Michigan Historical Museum Archives.*

Who fight a foe, by the unseen.
And of such men was Jefferson,
Compatriot of Washington—
Who, though himself to peace inclined,
Served with such brilliancy of mind
That, when war's end had been declared,
He too, the Nation's honors shared.
So great indeed, had grown his fame
That he was called upon to frame
The Constitution—that has stood
The test of time—and still holds good!
For in the drafting of that code
His own true principles he showed—
For 'twas in simple terms that he
Demanded full equality;
A daring thing to advocate
When failure meant a rebel's fate!
But threats of death convey no fright
For those whose cause is just and right.
And by that spirit they secured
The freedom that has since endured—
And none gave greater service than
Jefferson—the great Statesman!
The plow-boy who Virginia sent
To be our Country's president.
Gone is the man—but all may see
His monument—Equality!
And wise are they who yet shall heed
His principles of life and creed!

John Blood

Albert Ewert had very definite views on what he called the "New Social Concept." These views found expression via the new technology of radio. From the fifth floor of MSP, in Ewert's newly designed chapel, his sermons were broadcast, reaching a wide audience outside the prison walls. The broadcasts also featured inmates reading their poems and essays and playing music. One trio of jazz musicians became so popular from their prison broadcasts that they were hired on weekends to play at weddings and other celebrations. The chaplain's son, at age seventeen, became their chauffeur.

Harry Evans, alias John Blood, became poet laureate of MSP under chaplain Albert M. Ewert's arts rehabilitation reforms. *Courtesy of the Michigan State Archives.*

This author interviewed Quentin A. Ewert when he was ninety-three and asked if he had been afraid to drive three convicts to and from their gigs with no handcuffs and with no accompanying officers. He said, "No. They had nice uniforms for their gigs. They loved getting out, playing their music, hearing the applause and getting a few tender morsels of nonprison food. They would get back into the car, enter the prison walls, do their time all week and look forward to the next weekend."

Chaplain Ewert stirred up quite a bit of controversy when he allowed twenty-four inmates, incarcerated for all levels of crimes, to attend a Thanksgiving dinner at his home with his wife, Mable Beard Ewert, as the cook and hostess. He considered this an experiment in what happens when a criminal is treated with respect and trust and acquires some momentary relief from the unpleasant confines of prison, feeling the warmth of a genuine home. No incidents occurred, and those who attended were forever grateful for the glimpse of life on the outside. Controversy, however, existed in the ranks of the corrections officers. Yet when MSP closed in 1934, Albert M. Ewert gave up his work as a chaplain to become director of rehabilitation in the Michigan Department of Corrections. He served in this capacity until his retirement in 1952. What follows is one of his many statements on the New Social Concept:

Chaplain Ewert's services were broadcast on the radio. Inmate musicians and poets performed after the service. This popular trio entertained in town on the weekends. *Courtesy of Catherine Ewert Benson.*

The new social concept as applied to sociology and criminology...may be summarized in a few brief statements. First, removal of discretionary power from the judges thereby limiting all sentences without a minimum term of years; this would mean a judge establishes innocence or guilt only. If guilt is established the convicted man is sentenced to prison with no recommendation and with no minimum or maximum term. Secondly, the creation of a non-political Commission of five men whose foundations require their presence within the prison walls every day thereby bringing them in personal contact with the men. By this contact they would be afforded the opportunity of noting the progress made by each man. This Commission would be invested with the authority to determine prison routine and objective, placing the institution upon a strictly scientific and educational basis with social

adjustment and character building as the main objective. Fourth, changes in over 200 statutory laws and revisions.

...Each man entering the institution would know from the outset that his release depended upon himself and not upon the passing of years with the termination of his sentence in view. This would give rise to initiation on his part, confidence, self-respect and increased personal satisfaction in realizing his own true worth as an individual.

That the present system has fallen down is plain from the vast amount of data at hand relating to the results of a determined prison term and the difficulty the individual has in making good upon his release....If punitive methods are what we want together with all the undesirable phases incident thereto, then there is no sense in speaking of education and rehabilitation. If it is the latter we are striving for then we cannot progress from the premises belonging to a system conceived in medievalism.

Interestingly, many of the issues Albert Ewert puts forth in his writing were addressed, and advances were made, only to have the pendulum swing backward again, especially during the 1980s drug war, aspects of which continue today. Thousands of nonviolent offenders fill the prisons, and inequities exist in the form of lesser sentences for whites than for minorities, particularly African Americans. Solitary confinement still exists, but rather than dark dungeons and bread and water, many solitary cells have lights on twenty-four hours a day, which causes other kinds of damage. Incarcerated youths are punished for their boundless energy rather than given constructive outlets for this natural exuberance. Sentences are often indeterminate and parole very hard to come by.

There are institutions around the country with forward-looking ideas regarding incentives, education and humane treatment like those promoted by John H. Purves, H.F. Hatch and Albert M. Ewert. Michigan's first state prison, in spite of the medieval premises upon which it was founded, claimed three outstanding reformers.

13

The Closing of Michigan's First State Prison and the Near Canary Revolt

Overcrowded and outdated, Michigan's first state prison closed nearly twenty years after it was condemned. The new 57.6-acre State Prison of Southern Michigan became the largest walled prison in the world, giving Jackson the distinction of having the two largest penitentiaries known to date. SPSM had new health codes and flush toilets. Gone were the days of the honey buckets. The architecture allowed for a modicum of cross-ventilation, as the cells weren't lined up in rows with eighteen-inch walkways between them and the next row of cells almost like the combs in a beehive. Instead, cells lined each side of the area, with a huge open space between and steel bars on both the back and front of the cells.

Some memorable stories stemmed from MSP's closing. One concerned the inmate who'd grown up on a farm and had known nothing but outhouses and his honey bucket. When the bucket was removed as the inmate was being moved to the new prison, he grabbed it from the guard and refused to let go, terrified that he'd have no place to excrete. He was permitted to hold the bucket on the way to the new prison, his home for life. Upon arriving, it took four guards to overcome him and the grip he had on his "precious" bucket. Calming the inmate down, the guards showed him the wonderful flush toilet. When he heard its roaring noise and saw the churning water sucked down, his hysteria grew. He yelled, "I knew it! I knew it! You took me here to kill me. You intend to put me in that killer machine, and I will be gone!" Eventually, he learned what a flush toilet was and calmed down but most likely forever preferred his good ole' bucket!

Poorly behaved inmates cleaned the honey buckets. Waste went into the Grand River through a pipe deep under the ground. *Courtesy of Jackson Historic Prison Tours.*

What follows is a description of one of the most memorable farewells to MSP.

Birdcages housing canaries hung in the cellblocks from lattices outside nearly every cell. Like the canaries in coal mines that keeled over when the balance of gases and oxygen was out of whack, the canaries at MSP died when the methane gas from the honey buckets overwhelmed the oxygen. Twice a month, an inspector trained in methane inspected the cells at MSP. If the canaries were not singing or had keeled over, the prisoners were packed into the bullpen and anywhere else they could be taken while primitive methods were used to reinstate the proper balance of oxygen in the air.

At that time, Hartz Mountain produced two kinds of birdseed: one from corn seeds for common birds; the other derived from cannabis—wild marijuana seeds—for songbirds like canaries. You can imagine the joy at bird-feeding time as the men reached their arms out of their cells, saying, "Tweety, sweetie, wouldn't you like to share your dinner with me?" In addition, the canaries became beloved pets to the inmates. The canaries also hung in cages from the ceilings and walls of the factories, filled with noxious fumes.

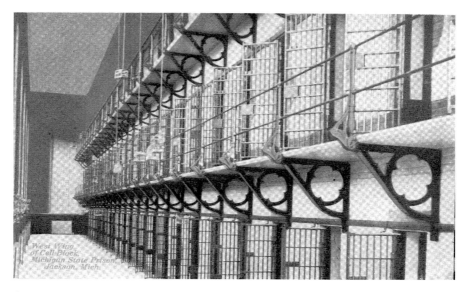

Canary cages hung from lattices over the cells. Birds died when levels of methane gas from honey buckets became dangerously high. *Courtesy of Jackson Historic Prison Tours.*

When MSP was closing, the officials announced that canaries were neither needed nor permissible at the new prison. Having been caged birds, releasing them to fend for themselves in the wild would be cruel. Therefore, all the canaries were to be killed. A near uprising occurred as the inmates protested vociferously. "No! Let them go! Open their cages. They want freedom, too. Let those that remember how to fly do so!"

Emotions grew so volatile that the officials, to prevent an outright riot, said they would hold a celebration on the prison yard. They'd feed the canaries and open the cages. Those that remembered how to fly could do so and try survival in the wild. The evening arrived. Hundreds of cages sat in the yard as hundreds of inmates, wishing they were those birds about to fly to their freedom, stood watching. The birds' last supper of wild marijuana seeds was administered. The cages were opened. Lo and behold! Hundreds upon hundreds of canaries flew skyward like beautiful yellow clouds. The cry of joyous prisoners rang through the air. "Free! Free! Free! Fly free!"

As the birds ascended to their newfound freedom, they did what birds do as they fly: they pooped. Down, down, down their poop fell, filled with wild marijuana seeds. As a result, not only does Jackson lay claim to the largest walled prison in the world, but as a result of this old bastion of prison life

and lore known as Jacktown, southeast Michigan lays claim to the largest wild marijuana crops in the United States!

And so, the era of the "Big House" came to an end, but not the growth of penitentiaries. Gone from prisons in America today are Codes of Silence, whippings, iron caps, riding the mare, dungeons for solitary confinement and other such medieval punishments. Yet the questions of how to deal with those who break the law are still debated. Who should or should not be confined within prisons and the society that prevails within them? How can fairness, justice and racial nondiscrimination be implemented? Should capital punishment be outlawed? Should education and work be fostered in prison? What level of medical treatment and psychological care should be implemented? Who belongs in a mental institution instead of behind prison bars? What is the role of privatization in the prison system? The list of questions goes on and on.

And the pendulum continues to swing, and politics continue.

14

THE GHOSTS MAKE THEIR APPEARANCES

Two weeks after moving into the old prison, now Armory Arts Village, my possessions arrived. One night, unpacking a tall box filled with knickknacks, I unloaded six exquisite blown-glass musicians that had belonged to my musician parents. I placed these on a shelf on a wooden corner-piece that now stood in the small alcove under the stairwell. Suddenly, the area turned bitterly cold. Before my eyes, the right-hand corners of the four shelves on the unit began bouncing up and down. I grabbed some of the glass figurines but quickly placed them down as the top shelf flew toward me. The shelf reversed and landed on top of all six figurines, not breaking them like glass in chunks and slivers but crushing them into colored snow that fell in a mound on the floor.

Crying and talking to something I couldn't see, I said, "Why did you do that? My parents were such nice people. These were a family heirloom. Oh, my God, I hope you like music, for I, too, am a musician." Realizing with deep sorrow that I'd never have those beautiful figurines back, I began offering the thing I felt and could not see nonbreakable objects for appeasement. The next day, my files, packed in plastic milk crates locked and stacked one atop the other, gave me another shock. Standing in my loft, I witnessed the top crate lift itself off, fly across the room and land on the top of the stairwell and the files tumble down.

I called Catherine Ewert Benson, with whom I had heard an architect speak. The architect claimed that for forty years he'd renovated only historic buildings. Never had he renovated one where strange things didn't happen.

He cited Albert Einstein's formula $E=MC^2$. Energy does not disappear. It simply comes back in different forms.

Catherine came to my apartment and brought the crucifix that had hung in her grandfather's office when he was the last chaplain in the old prison. She hung it on the wall in the small alcove under the stairwell. As a Jewish person, I would not normally hang a crucifix, but I was honored to have such an artifact from a man as outstanding as Albert M. Ewert. "Grandma," I looked upward and said, "trust me wherever you are. I am not converting. This is just a very particular situation."

The crucifix seemed to do the trick. Things calmed down. Nothing went flying and nothing was broken. Instead, my seven music boxes went on at 12:01 a.m. for nearly six weeks—on, then off, one, then another, like a Bach fugue. Ten little frogs that would light up when put on a moist area sat on the moisture-free ledge of my loft. At 4:00 p.m. each day, they all lit up—on, off, on, off—until the batteries died some three weeks later.

Even years after closing, the dungeon-like solitary area retained a grim atmosphere. There have been numerous sightings of orbs and many paranormal occurrences. *Courtesy of Armory Arts photographer Jon Tulloch.*

One evening, while cooking dinner, I heard a sound like a crackling fire behind me. Turning quickly around, I saw a face clear as day on my television, which had turned itself on, though the background was completely black. There, a man dressed in an old-fashioned suit jacket and tie stared at me. He looked identical to an archival photo of a man with several prisoners in striped uniforms. After about thirty seconds, the image left and the television clicked off. A few minutes later, the same thing happened, and the man appeared again. For a few seconds his image flickered on and off, then faded forever.

At a meeting in an artist's studio, the heavy, closed door opened itself. No one was there. Appointed "Ghost Whisperer" of the place, I went over to the door and said, "We are at a meeting. Whether you come in or stay out, please close the door." Whatever it was promptly obliged.

Several dogs in the building still bark vociferously for minutes at a time at things their owners cannot see. They stop as quickly as they start, when whatever excites them departs. A repairman who had worked on the building during its renovation informed me that he'd signed up for night duty as a watchman with another worker. After three days, in spite of the high pay, the two quit. They heard screams echoing from the tunnels underneath, dogs barking where no dogs existed, whips lashing and the sounds of footsteps behind them but only the empty night when the men turned around.

Photos reveal hundreds of pure orbs in the old West Wing cellblock, now the Grand Gallery. Orbs, as seen in the accompanying image, have been photographed in the former solitary area. An artist hung her paintings on the wall over her mantel. Constantly, one of them—the same one—kept flying off the hook upon which it hung. She took a photo. In that exact spot, her camera snapped a pure orb. She photographed the wall behind the other paintings hanging over the mantel, but they revealed nothing.

In one of the underground tunnels, I suddenly felt the presence of three energies, all at varying distances from my left shoulder. It felt as though something or someone was knocking me down. I began to lose my balance. I yelled to photographer Jon Tulloch, who was at the other end of the tunnel, to quickly come and help me. As he ran toward the spot, he photographed it. Sure enough, there were three orbs just where I'd felt them and at the distances I described. As Jon came running, his camera caught the three orbs rapidly dropping to the ground and rolling fast ahead of me. Perhaps they were the ghosts of guards who thought I

A particular painting, hung the same way as the others, kept flying off the wall. This artist's photo shows a pure orb at the exact spot where this particular painting hung. *Courtesy of Armory Arts artist Jennifer Redemsky.*

was an escaped prisoner, or perhaps they were three prisoners about to attack me, thinking I was a guard.

The Grand Rapids NBC affiliate was filming a report on the Historic Prison Tours. Their contact equipment shut off six times while attempting to connect with their central tech station. That had never happened to them on any of their film shoots. I had a little talk with the old inmates and told them to stop, that we had work to do. Apparently they listened, for the equipment remained on after my admonishments.

A couple of years after I moved in, a paranormal group with EVP (electronic voice projection) equipment had me ask who broke the glass figurines. After repeating the question several times, the answer came in a muffled voice: "Owace." I couldn't decipher Lawrence or Horace. It continued, "Murphy—Owace Murphy—murdered in cell." There was a Horace Murphy here who never got out. His descendants took our tour and are attempting to find out what their ancestor did to end up

in Jacktown and why and how he disappeared here. That same night, in answer to my question, "Who turned my music boxes on?," a voice answered, "Prankster here, prankster here." Behind him came a voice, "Reverend visits, Reverend here." And I was told that at the top of my stairs there is a vortex through which those who have gone to the light or wherever can return to this plane to visit. In all the years living here, I have experienced an intense energy coming from just that area every night as I go upstairs to bed and when I awake in the night to walk to the bathroom. It feels like heat, light, balls of energy and bees buzzing.

THE CROW

Night keeper John H. Purves wrote in his reports of 1882 about an inmate who inhabited a cell somewhere in the center cellblock, where my apartment now exists. The inmate occupied his cell on the second gallery, where my loft is today. At night, when all was quiet and snores rather than yelps and other noises filled the air, this inmate would loudly yell, "Caw! Caw!" sounding like a crow. The other inmates would cry out, "Shut him up!" The guards' clanking boots could be heard running toward the sound. The old prison echoed, as did the "caws." The inmate, hearing the sound of boots, stopped. Just which cell "The Crow" (as he came to be known) resided in was never discovered. Of course, no one would snitch for fear of his life. So, his identity remains unknown to this day.

During my first spring in Jackson, robins, cardinals and other pretty birds landed frequently on my window ledge. As soon as they'd see my shadow or hear a noise, they'd fly away in fright. One day, when I was upstairs in my loft, I heard a raucous, loud "Caw! Caw!" I thought one of two things: I was losing my mind, or I would go downstairs and find a milky-white ghost of a former inmate. Instead, on my window ledge sat a huge black crow cawing away. I went to the window and banged on it, but that didn't frighten the critter. He remained there, loudly crowing nonstop. Before I knew it, I was bending down, looking the bird in the eye and responding with, "Caw, caw, caw!"

"Caw, caw, caaaawww," he answered.

"Caw, ca-ca-ca caw," I replied. This went on for several minutes until—boing!—$E=MC^2$ popped into my head. I looked that bird right in the eye and said, "Are you 'The Crow' come back in this life in the form of the animal you used to imitate?"

Author Judy Gail Krasnow communicated with a crow that wouldn't go away. Was this bird the incarnation of a former inmate known as "The Crow"? *Author's collection. Illustration, Armory Arts artist Louis Cubille.*

That bird stared straight at me and answered, "Caw, caw, caw!" Then it tapped its beak three times on my window and let out a resonating "CAAAAAWWWWW," turned around and flew away. For eight years I have lived here, never again seeing a crow outside my window. As a matter of fact, we do not get crows in this area.

I believe I had a conversation with a former inmate of Michigan's first state prison, albeit in a language I don't quite understand. You should try crowing. It really feels good and lets out all sorts of feelings. Perhaps that is why the mysterious inmate known as "The Crow" cawed each night.

TODAY

Things have definitely calmed down in the years that the old prison has served as Armory Arts Village. Energy also replaces energy. It is a genuinely nice place, listed on MSN.com in the top ten list of most unique buildings in the world in which to live. And it is not scary at all. The building is like a mighty fortress; it is the safest place to be in a storm or tornado. The architects definitely kept the integrity of the building's history intact and didn't drywall the whole place or carpet the lobby. This is a highly historic remaining section of a former prison. They even left the bars on many windows. It has character.

An overview of Mechanic Street, filled with factories where inmates toiled. The prison could be seen from all directions. *Courtesy of Jackson District Library.*

Woodlawn Cemetery is where many MSP inmates lie, with no names or inscriptions appearing on gravestones. *Author's collection. Photographer, Jon Tulloch; muralists, Hector Trujillo and Jean Weir; historian, Judy Krasnow.*

Yet for anyone who believes what Albert Einstein's theory revealed, an old historic building can never totally let go of all the people and events that took place there. The energy is absorbed by even nonliving brick, stone, mortar, concrete, floors and ceilings. If these walls could talk, what stories they would tell. These walls spoke to me and continue to do so. I hope you enjoy the stories they have shared.

AFTERWORD

January 17, 2009
Dear Miss Krasnow:
Sorry for the delay in writing to you as I said I would. No excuses.

My father, William Thomas Hillard, was a lumberman and a farmer prior to moving to Jackson in 1922. He was a camp boss in several lumber camps in and around Cadillac, Michigan. (That is another story.) His farming days were spent in the Coopersville, Michigan area, where he was born.

Times were tough for a tenant farmer in 1922, and his brother, Elmer Hillard, talked him into moving to Jackson and applying for a job at the prison. His brother had worked as a guard at the prison for many years. William applied for the job and began working as a guard in late 1922 or early 1923.

His post was located on the north wall, which ran along North Street. The wall and his post still stand, as you know, and I hope it will remain part of the prison history.

He worked the 11:00 p.m. to 7:00 a.m. shift; nights were usually calm and quiet. That changed one night while William was cleaning his gun. His knowledge of gun safety was good, but it failed him this time. He forgot to remove the bullet, and the gun fired. The noise brought others running to see what had happened. (This was, of course, in the days before cell phones.) He thought that he would be fired for such neglect but, for some reason, he was not.

The guards' lot was no more comfortable than that of the prisoners, especially in the winter. Heat and lights were few and far between in the cells and on the wall. The wind swept down the wall and could set your teeth to chattering.

A variety of food was not available, and the same menu was served to the prisoners and the employees. I remember one morning when my father brought home a sandwich that had been given him for his lunch that night. The bread was hard and coarse. The thin slice of beef in the sandwich was tough. Our father told us not to drop it on our foot, as it would probably hurt us. He had always taken a sack lunch with him to work, and now we knew why. He finally gave it to the dog. The dog would not eat it.

When the prison transferred its facility to the new prison in 1935, William did not go. He was sixty-seven. He had worked for the prison for twelve years. I remember he hired out to a farmer in the area after that, but he died of a heart attack in 1937.

My son-in-law retired from the prison in April of this past year. In his position, he worked among the prisoners and did not carry a gun. A conversation between an inmate of the old prison and one confined at the present site would be very interesting. The prisons, both old and new, have been a source of employment for many Jacksonians, and they continue to be after 170 years.

The theme of your tour of the old prison, "From historic prison to artistic vision," is very appropriate. It is a wonderful opportunity for those who take the tour to learn about Armory Arts Village. As you said, many people do want to sweep prison history away, but I am proud to have been a part of it through my father.

Sincerely submitted,
Violette A. Neel

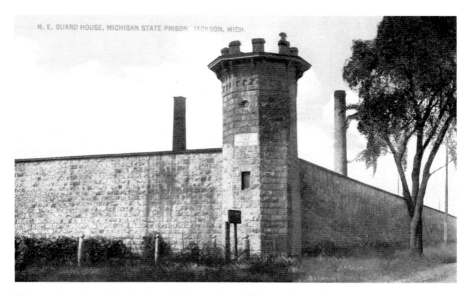

The north wall and North Guard Tower, where Violette Neel's father held his post as a guard, even on the coldest winter nights. *Courtesy of Jackson District Library.*

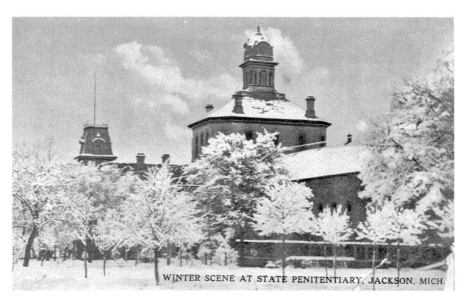

A winter view of MSP. Night keeper John H. Purves wrote that, while he was on his rounds, he could hear the sound of 328 jaws of chattering teeth. *Courtesy of Jackson District Library.*

BIBLIOGRAPHY

Andrews, William. *Old Time Punishments*. New York: Dorset Press, 1991.

Blanchard, G.L. *The Man Who Traded His Wife for Woodworking Tools & Other True Stories of Jackson, Michigan in the 19ᵗʰ Century.* Charleston, SC: CreateSpace, 2010.

Bright, Charles. *The Powers That Punish: Prison and Politics in the Era of the "Big House," 1920–1955.* Ann Arbor: University of Michigan Press, 1996.

Brumm, Leonard "Oakie." *We Only Played Home Games.* Milwaukee, WI: Brumm Enterprises LLC, 1950.

Cox, Stephen. *The Big House: Image and Reality of the American Prison.* New Haven and New London, CT: Yale University Press, 2009.

Darrow, Clarence. *Crime, Its Cause and Treatment.* New York: Thomas Y. Crowell Company, 1922.

Ella Sharp Museum. *The History of Business and Industry in Jackson, Michigan.* St. Louis, MO: G. Bradley Publishing, Inc., 1993.

Gaines, Thomas S. *Buried Alive (Behind Prison Walls) for a Quarter of a Century: Life of William Walker.* Saginaw, MI: Friedman & Hynan, Publishers, 1892. Reprint, Seattle, WA: CreateSpace, 2012.

Jackson, Harry H. *The Michigan State Prison, Jackson, 1837–1928.* Lansing, MI: State Prison Commission, 1928.

Johnson, Perry M. *The Rise and Fall of the World's Largest Walled Prison: A History and a Memoir.* N.p.: self-published, 2015.

Kavieff, Paul R. *The Violent Years: Prohibition and the Detroit Mobs.* Fort Lee, NJ: Barricade Books, 2001.

London, Jack. *The Road*. New York: Penguin Books, 1999.

Martin, John Bartlow. *Break Down the Walls: American Prisons, Past, Present, and Future*. New York: Ballantine Books, 1954.

Powers, Tom. *Michigan Rogues, Desperados, Cut-Throats: A Gallery of 19ᵗʰ Century Miscreants*. Holt, MI: Thunder Bay Press, 2002.

Purves, John H. *The Night Keeper's Reports*. Published in the United States of America by the Printing Department of the State of Michigan. Lansing, 1917. Reprint, n.p.: State Prison of Southern Michigan, 1954, 1957, 1965, 1973 and 1977.

Reynolds, John N. *The Twin Hells: A Thrilling Narrative of Life in the Kansas and Missouri Penitentiaries*. Atchison, KS: FQ Books, 2010. Reprint, Ann Arbor, MI: Palala Press, 2016.

Rubenstein, Bruce A., and Lawrence E. Ziewac. *Three Bullets Sealed His Lips*. East Lansing: Michigan State University Press, 1987.

Testimony Taken in an Investigation Before a Joint Committee of the Michigan Legislature of 1875, Touching the Administration of the Affairs of the State Prison at Jackson. By Authority. W.S. George & Co., State Printers and Binders. Lansing: Michigan Historical Reprint Series, 1875. Reprints from the collection of the University of Michigan University Library.

Waller, James. *Becoming Evil: How Ordinary People Commit Genocide and Mass Killing*. New York: Oxford University Press, 2007.

Wood, Ike. *One Hundred Years at Hard Labor: A History of Marquette State Prison*. Au Train, MI: KA-ED Publishing Company, 1985.

Zimbardo, Philip. *The Lucifer Effect: Understanding How Good People Turn Evil*. New York: Random House, 2008.

Miscellaneous Papers

Bacon, Illa J. "The State Prison of Southern Michigan 1837–1959." Term paper. April 21, 1959. Jackson District Library.

Briggs, Charles Augustus. *History of Jackson County, Michigan*. Jackson County Online Library.

History of State Prison of Southern Michigan. Lansing: Michigan State Library. Official Collection Michigan Documents. CR 2/A672.

Kobs, Peter Lynch. "The Chain of Vindication: Prison Labor, Railroad Conspiracy, and the Fusion of Antislavery in Jackson County, Michigan, 1829–1870." Thesis, Brown University, April 1980.

National Register of Historic Places Inventory Nomination Form. Michigan State Prison. Michigan Historical Commission Registered State Site No. 178, Historic American Engineering Record, 1958 and 1975. Michigan Historical Division, Michigan Department of State.

Rothman, David J. *The Discovery of the Asylum.* Chapter Three: "The Prison and Prosperity." Aldine Transaction. New Brunswick, NJ, and London, 1971.

Various letters written by inmates to Chaplain Albert M. Ewert and excerpts from early issues of the prison publication *The Spectator* (1933–34). Jackson and Lansing: Michigan State Archives.

Index

ABOUT THE AUTHOR

Judy Gail Krasnow is the founder and director of Jackson Historic Prison Tours, leading tour groups through the history and tales of Jackson's State Prison. She lives in Armory Arts Village, a resident artists' community converted from Michigan's first state prison. Judy is the author of a memoir about her father, Hecky Krasnow, *Rudolph, Frosty, and Captain Kangaroo.* She is a Chautauqua scholar and performance artist with various humanities councils and presents historical storytelling programs and portrayals about women who have left their marks on history.